YOU WILL

BE ABLE TO

COLLAGE

BY THE END

OF THIS

BOOK

Stephanie Hartman

ilex

CONTENTS

A NOTE ON PAPER

Throughout the text, where I've referred to paper size, I've included both the international ISO 216 standard (which includes A4 and A3) and the most obvious North American corresponding size (letter and tabloid, respectively). Although these aren't exact equivalents, they're a useful guide to the paper size to use in each project.

Collage, from the French verb *coller* meaning 'to stick', refers both to finished artworks and the technique used to make them. Materials are combined and stuck down on a larger surface to form a composition. It's an incredibly versatile medium and an accessible technique that everyone can have a go at.

INTRODUCTION

This book is a celebration of the vast and varied ways collages can be made, providing you with a series of step-by-step projects that use different materials, techniques and themes, plus plenty of ideas to spark inventive ways of thinking about your own artworks beyond these pages. As well as giving you practical tips, it will give you the freedom to explore ideas without fear of messing up. The beauty of collage is that there's really no right or wrong way to approach it, making it a lovely place to start if you're looking to reconnect with your creative side.

As well as achieving beautiful end results, I hope you find the process of cutting and sticking just as rewarding. I can spend ages completely absorbed in making, not realizing hours have passed. There's something wonderfully meditative about the process that I hope you embrace. In our busy lives, we rarely give ourselves time to make for making's sake or space to pursue play.

I've loved collage for as long as I can remember, spending much of my childhood chopping paper into intricate patterns, before moving on to magazines in my teens and filling endless scrapbooks with reworked pages. I studied illustration at university, with collage threading itself through every project, and I now spend my time running collage workshops, sharing my passion for the art of ripping and sticking and providing a creative space for people to switch off from the day-to-day. My obsession with the medium has not dwindled and I'm delighted I can pass it on to you now through these pages.

What I'm so drawn to is the infinite possibilities collage provides, with an artwork able to exist in so many states before you commit to it with glue. I love the happy accidents that occur when disparate images are placed together to form new narratives, and the element of chance that is intrinsically part of the process when hunting for imagery. I also believe there's something hugely rewarding about using your hands to make physical, tactile things – it's good for the soul!

First coined as a modern art term by Cubist artists Georges Braque and Pablo Picasso, collage entered our lexicon when the pair began incorporating found imagery and objects into their work at the beginning of the 20th century. Although technically an assemblage, *Still Life with Chair Caning* (1912) is often described as Picasso's very first collage. Other artists associated with the movement, such as Juan Gris, soon developed an interest in the technique and it became an integral method of making for the artistic movements that followed, including Futurism, Dadaism and Surrealism.

Despite not having been referred to as 'collage' in an artistic sense before then, the act of cutting and pasting to create art has been around for hundreds of years, with text-based collages formed in Japan in the 1100s and Western examples of collage emerging in the 1400s. A vast array of collage works were made in the period around the 1900s in Europe, and the Victorians were utterly obsessed with it, but terms such as 'mosaic work', 'adornment' and 'découpage' were usually used to describe it and the activity was often dismissed as a hobby, or something for amateurs, women and children.

For me, collage is for everyone and can be approached in any way you see fit. It can be a means of expression, a brilliant tool for communicating ideas and a way of understanding the world around you.

'...make the mundane magnificent.'

Play

Play is a word I want you to keep front and centre. The collage process is so much fun! It's important to carve out time to play and collage is the perfect vehicle for it, giving space for creative mistakes and silly, surreal compositions to be made. Tap into your inner child and make for the enjoyment alone. Allow yourself time just to experiment without a clear end goal in mind and good things will happen.

Endless possibilities

Collage is a technique with infinite potential. There are myriad ways any single composition can come together, meaning there are no set rules or right ways to do something. Let intuition do the heavy lifting when it comes to making creative decisions.

I believe even seemingly boring materials have something going for them. While a dull magazine might not have figurative imagery you're excited about, I bet it has interesting textures or patterns that can be transformed into something remarkable. Challenge yourself to make the mundane magnificent.

Reuse and recycle

Wherever possible, I encourage you to incorporate what you have around you into your work. Save things from the recycling bin, raid charity shops for magazines and squirrel away packaging for assemblages. We all need to do our bit for the planet and collaging is a brilliant way to breathe new life into materials at the end of their intended lifespan. You'll find a segment in this book dedicated to scraps and how you can utilize every last inch of the papers you snip, reducing waste even more.

Inspiration is everywhere

The names of collage artists are sprinkled across this book and can be researched further if you're drawn to a particular style or method.

Beyond collage, there's inspiration to be found absolutely anywhere. Notice everything! Pleasing colour combinations, the pattern made when light dapples and dances across a pavement, or the aesthetic of a film you love. Don't dismiss the little things that bring you joy, as they might plant a seed for an excellent artwork.

The book is split into two main parts that cover paper-cut collage and working with found imagery. A final, third section looks at how collage can move beyond two-dimensional works. While divided by material for ease, there's nothing stopping you from combining materials, and as you build confidence, you'll probably find this is something you do intuitively when it feels right.

HOW TO USE THIS BOOK

The step-by-step projects are intended as a jumping-off point for your own ideas and you can borrow and modify the bits you like best to shape your practice. If you're a total beginner, work your way through each project in order, but if you've dabbled before, feel free to dive in wherever you feel inspired.

Approach this book as a series of experiments that will allow you to sample lots of techniques in relatively quick succession. Some you'll connect with from the off and others you may need to work at for longer to get the results you want. You'll soon discover your favourite materials and styles, so let your scissors guide the way and enjoy the journey. By the end of this book, you'll be armed with new skills and ways of looking, plus you'll have developed the confidence to pursue paper projects of all kinds.

Collage glossary

The word collage is used in this book as an umbrella term for all the types and techniques available to you as a maker. Here are a few definitions for associated terms.

Papier collé

This term translates as 'pasted paper' and refers to collages made solely with paper and no other two-dimensional additions. It is mainly used when referencing those first collages made by Braque and Picasso.

Photomontage

A photomontage is a composite image made using two or more photographs. The Dadaists, including artists such as Hannah Höch, Max Ernst and Raoul Hausmann, adopted the method in the early 20th century and used it as a

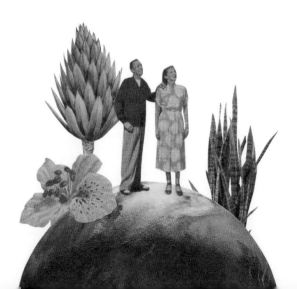

vehicle for political protest during World War One. The Surrealists took it on slightly later in the century, using it as a tool for expressing the unconscious mind.

Mixed media
This simply means artworks that are made from a combination of different materials: magazine pages, junk mail, fabric, paint, ink etc., all used within the same piece.

Assemblage
Assemblage is collage in three-dimensional form. Assemblages are made from everyday objects, often collected by the artist and including things such as wood, metal, packaging, fabric and found items.

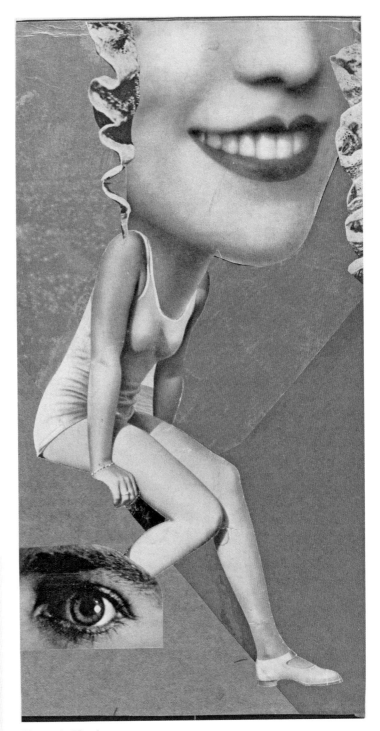

Hannah Höch
Für ein Fest Gemacht (Made for a Party), 1936

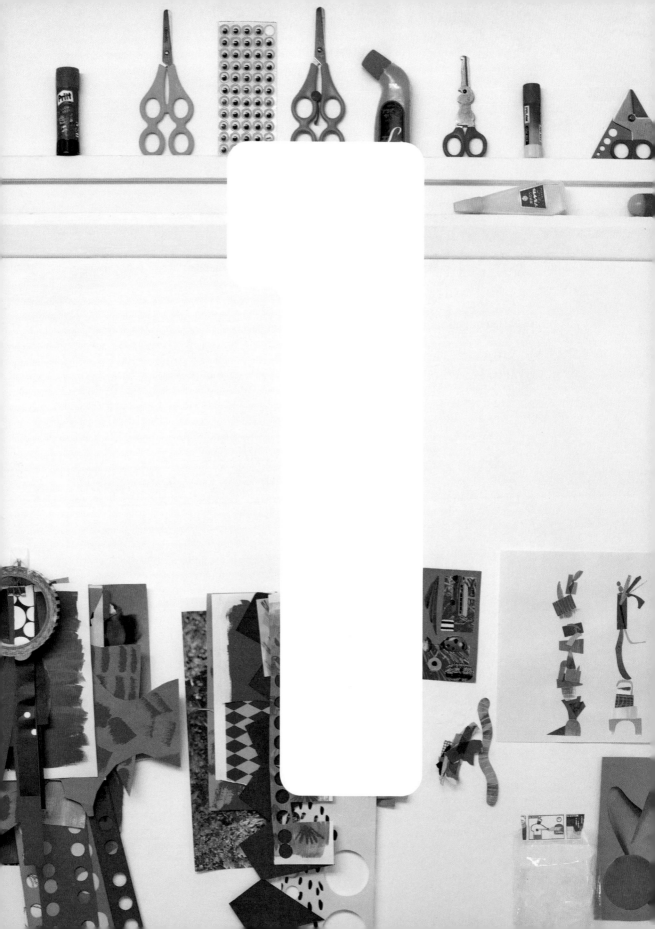

GETTING STARTED

Beginning something new can feel a little intimidating, but chances are you'll feel right at home with a glue stick and scissors in no time. The next few pages cover the types of adhesives, cutting tools and papers you might want to test out, and will also show you how to prepare painted sheets for use in projects later on in the book.

You'll also find a series of warm-up activities that will loosen you up and get your mind firing off lots of ideas in a short space of time. You can use them when you first sit down to make, or refer back to them when you're feeling stuck and need to mix things up. Remember to stay playful in your approach and embrace the creative accidents. The process is just as important as the final outcome, and if at first you don't succeed, rip, stick and collage again!

As you start your collaging journey, you'll begin to decipher the materials that best suit your way of working and personal aesthetic. You don't need lots of expensive kit to get started, and you may find you have things around the house already that are just waiting to be worked into a composition. There are endless types of paper, glue, scissors and other materials at a collage maker's disposal and I suggest trying out numerous variations until you find a combination that sticks.

MATERIALS + TOOLS

MATERIALS

Here's a list of possible materials you could add to your collage kit, but what's available goes far beyond the pages of this book, so don't be afraid to try out anything you come across.

Substrates
This is the surface onto which you collage. You want your support to be strong enough to hold the weight of whatever you're gluing on top. You can back lightweight pieces of paper onto sturdier surfaces if required.

Heavyweight, acid-free papers
Acid-free papers are great for collaging, as they won't fade or yellow in the way that other papers can. I particularly like using Clairefontaine Multi-Techniques 'Naturel' 250gsm pads. A collection of white, black and neutral tones is useful to have, alongside a collection of your favourite colours.

Materials destined for recycling

Keep the back boards from the pads of paper you buy. They are nice and thick, and are often a lovely speckled grey or brown. They look great with both bright and muted papers collaged on top. Keep hold of any nice pieces of cardboard normally marked for the recycling bin, too.

Other substrates

Cotton-rag paper
Pieces of wood
Watercolour boards and papers
Canvas
Fabric
Mountboards

Paper and card

There are so many paper styles to choose from. You can buy pads of paper as well as single sheets from art supply shops and build a library of textures and styles to dip into whenever you need. Some types such as sugar papers and tissue can fade easily, so do be aware of this when using them.

Coloured paper
Sugar paper
Technical papers – tracing paper, graph paper, lined paper etc.
Foiled paper
Handmade Japanese papers
Marbled paper
Origami paper
Newsprint
Tissue paper
Crepe paper
Kraft paper
Corrugated card

Found materials

For the Found Imagery section (see page 84), magazines are the main source material used. For mixed media and assemblage work, you might also collect:

Old books
Tickets
Stamps
Packaging
Posters
Envelopes
Junk mail
Maps
Vintage photographs
Wallpaper samples
Wrapping paper
Newspaper
Postcards
Sweet wrappers

Pre-existing artworks – drawings, paintings and collages ready to be chopped up into something new

Beyond paper

Tape – washi tape, masking tape, gaffer tape
Stickers
Labels
Fabric swatches
String
Letraset
Wooden shapes
Sheet vinyl

TOOLS

All you really need to get started with collage is a pair of scissors and some glue. As with the materials, begin with the essentials and build a collection of tools that complement the way you work.

Scissors
I have a range of scissors on my desk for different tasks – a large pair for quickly cutting out generous, rough shapes or slicing down big sheets and a small pair for intricate cutting. Find scissors that fit your hand well.

Craft knife
Craft knives are perfect for tackling fiddly imagery. Again, there are many types to choose from, so shop around for the one you like using best. They need to be used with great care, as they are incredibly sharp. Desks can get messy quickly when collaging, so ensure you know where your knife is – don't let paper pile up on top so it becomes hidden from view.

Cutting mat
I have a giant cutting mat on my desk so I'm ready to collage at any time, but I also have small mats that I can take with me to other locations. You'll want one while using a craft knife to protect the surface below.

Hole punches
From standard small holes to elaborate shapes, you can find a whole range of cutters and punches online and in craft shops.

Glue
My favourite type of glue is Coccoina Mia, an Italian white vinyl glue that smells like almonds. I decant small amounts and use a brush to apply it. It holds extremely well almost instantly, so you need to be sure of your placement when using it.

Many collage artists like to use gel mediums, which are fast drying and last for years. You can choose between gloss and matte finishes and they come in various thicknesses (and can be watered down if needed). I rarely varnish my work, but if you'd like to, gel mediums work well, as they dry completely clear. PVA can be used, too.

Glue sticks are useful for collaging on the go and for fast-paced warm-up activities. The glue has a small grace period before

Getting started

fully adhering to a page, so you can make last-minute adjustments if needed. Glue sticks aren't as hard wearing as other types of glue and can crumble and lose their adhesion over time.

Much stronger superglues will be needed if you're creating assemblages with heavier materials.

Blu Tack (reusable adhesive)

This is useful for keeping elements in place while you're working on a collage. I use tiny pieces to keep my images from shifting.

Sticky foam pads

These are great for lifting parts of your collage away from your page to add subtle depth. They come in varying thicknesses and can be doubled up if needed.

Other useful tools

You will need a variety of brushes for applying liquid glue and for painting your paper.

Paper tweezers are a godsend for precise placement of small imagery. I use curved, fine-tip tweezers.

A ruler is essential for achieving straight lines and for use with a craft knife. I have both a 15cm (6in) ruler for

small work and a 50cm (20in) ruler for larger sheets.

You will also need pencils for drawing shapes and an eraser for removing anchor lines. Try and source a high-quality one that won't leave marks on your page. Test it out on scrap first.

A bone folder is traditionally used by bookbinders and is a nifty tool for making a crisp paper fold.

Use a scanner for digitizing and documenting your work.

Portable scanners are easy to move around and take on trips away. I like to scan work while I'm working, as flattening the image helps me ensure the composition looks good.

Alongside working onto single sheets, it's useful to keep sketchbooks so you can jot down ideas, sketch and keep a record of colour swatches.

On page 21, you'll find the materials to create your own painted papers too.

Sourcing your collage materials

If you're drawn to the collage process, it's likely you're a keen collector – or at least you will be soon. You'll develop a magpie's eye for imagery that could work its way into an artwork or a type of paper that lends itself well to your style.

Good-quality magazines can be expensive and you might not fancy chopping up your favourites. Charity shops, boot fairs and scrap stores are brimming with magazines and you can often get lucky with bulk listings on sites such as Gumtree, Freecycle, Facebook Marketplace and eBay. Ask friends and neighbours to save any they might be chucking out and you'll have a collection in no time.

Scour cheap shops, independent stationers, junk shops and markets for deadstock papers, old photographs and packaging, and collect beautiful ephemera from trips abroad.

Like inspiration, materials can be found everywhere and anywhere, so don't discount a thing. Keep things from everyday life that might double up as collage treasure.

Top tip: Use washi tape to label your boxes so you can easily peel it off if the contents change.

Storing and taking care of your materials

Like the collage materials themselves, your storage solutions don't need to be fancy or expensive. Begin with what you have available around the house and upgrade if and when you feel you need to. The main thing to remember is that paper can fade over time and lose its colour, so be sure to store it out of direct sunlight.

Grouping my materials by theme works best for me. I divide my magazines by type: fashion, art, interiors, nature, architecture, lifestyle etc. It makes searching for a certain type of image easy and efficient. If you've cut a magazine to within an inch of its life, remove any final pages with potential and recycle the rest. Use a drawer or folder to store single sheets.

For storing smaller snippets of imagery, offcuts of painted paper and pre-cut shapes, clear boxes are great, as you can quickly identify what's inside. Labelled shoeboxes will also work nicely. Keep magazine imagery and painted paper separate if possible.

Sometimes, you'll find an image that's a perfect fit for something you're working on there and then. Other times, you'll have an idea that percolates for a while and will require you to look for imagery over the course of a few days or weeks.

When this happens, I have a number of clear envelopes on hand that can be labelled with the theme or idea and I add imagery whenever I find it. Clip them to your wall so you see them on a regular basis and can add to them with ease.

For full-size pages of painted paper, I use document folders with plastic sleeves and group my sheets by colour. They're not glamorous, but are efficient and protect the papers well.

Drawers, filing cabinets and planchests are great for larger sheets if you have the space.

Keep a lidded pot on your desk for used scalpel blades. This keeps them all in one place and you can dispose of them in bulk.

Top tip: The cellophane wrappers on greetings cards come in useful for storing small images, so don't throw them away. Similarly, bulldog clips are a good way of keeping elements and thematic magazine pages together without damaging the paper.

Copyright

When it comes to collage, copyright is something you need to consider if you have plans for your work beyond making for the joy alone. If you're collaging purely for yourself and to give to friends and family, then there's no need to get hung up on whether an image is subject to copyright, but things get murkier if you plan to put your work out into the world in a bigger way and monetize what you're making.

The easiest way to avoid copyright issues is to create collages that don't incorporate others' work. There's no worry with pieces made from coloured paper, painted papers and photographs you've taken yourself. Issues arise when found imagery made by others is incorporated, as it may be protected by copyright. As a general rule, in the UK and EU works are protected for the lifetime of the artist, plus a further 70 years after their death.

Collage by its very nature is concerned with borrowing and reworking imagery, assigning fresh meaning to form new narratives. Because of this, it could be argued that using someone else's artwork within your own is fine because it has gone through a transformational process, but it can be hard to argue fair use. Because it is so subjective, there's no hard and fast rule when it comes to usage and works are assessed on a case-by-case basis. What one person may consider a substantial reproduction of a work may differ entirely from someone else's view. Completely obscuring imagery and using small snippets to ensure found imagery is unrecognizable is a safe way to avoid infringement, as is using copyright-free imagery. If that isn't feasible, permission needs to be sought from the copyright holder before the work is used.

Museum websites are great places to source imagery, as many have archives loaded with copyright-free material that can be downloaded and printed. There are also physical books to buy, which are often curated to specific themes, although primarily filled with illustrations rather than photographs. Although using this type of imagery eliminates the worry of infringement, it does of course mean the spontaneous nature and chance element of collage is removed, as planning is required when searching for copyright-free imagery.

Please don't let what's outlined above put you off using magazine material completely, but do be mindful of how you're using it if the plans for your collage works become grander.

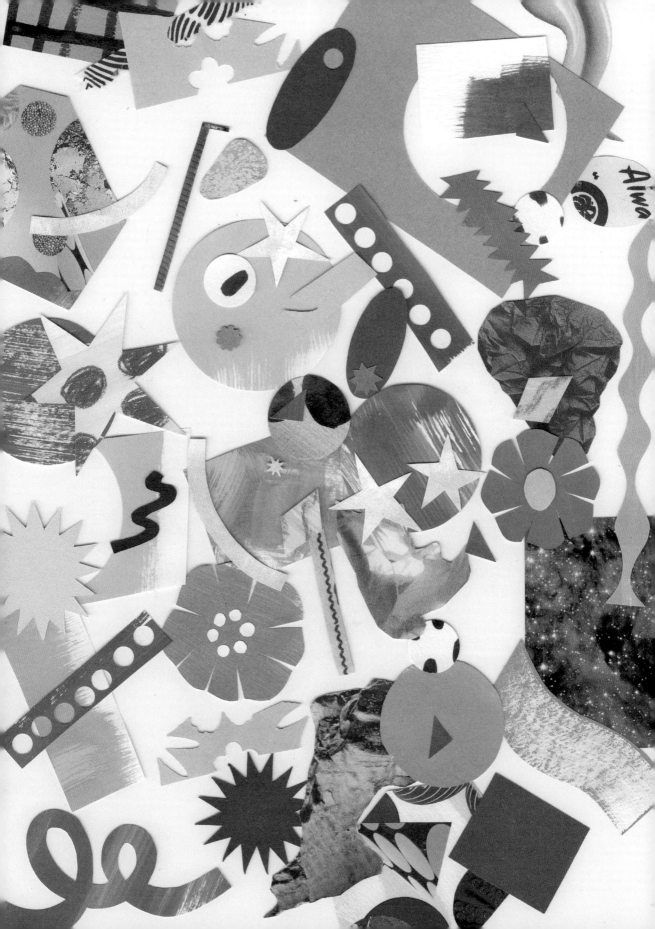

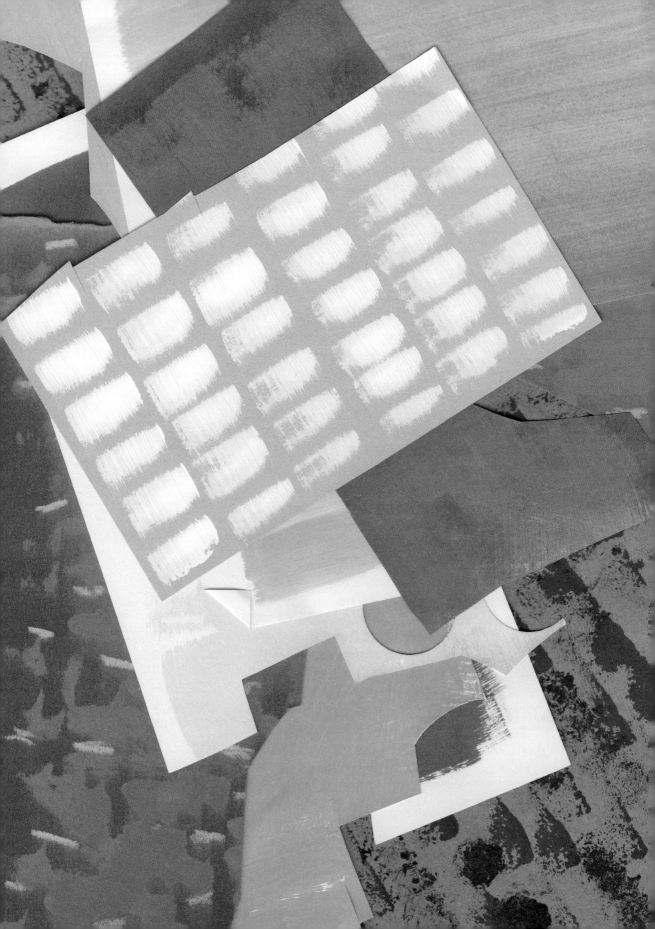

I love creating painted paper and often find it just as enjoyable as the collage process itself. I regularly spend a whole morning preparing sheets of paper for use at a later date.

CREATING PAINTED PAPERS

Possible materials:
Acrylic paint
Gouache paint
Watercolour paints
A range of paintbrushes
Sponges
Toothbrushes
Wax pastels

Top tip: As well as having a few different types of paint and ink to work with, consider the texture of the paper you're painting onto. The surface of your paper will change the way the paint looks once applied, so play around with smooth, textured and tissue papers to determine your favourite aesthetic.

There are so many ways to paint your own paper and I suggest being as playful and experimental as possible when you first begin. You'll soon work out what works best for your collage style, whether that's creating solid colour or textured or patterned sheets.

As well as paintbrushes, you can use unexpected objects and tools to create texture and patterns. Across these pages, I've used a toothbrush, kitchen sponges and cotton buds. I also use a candle (a cheap, colourless dinner candle is ideal) to create wax-relief patterns. It requires a bit of guesswork, as you can't really see the pattern you're making on your page, but once you paint over the top, shapes and lines will be revealed to you like magic.

I most frequently use acrylic and gouache paints, as they're quick drying, vibrant and easy to mix. You can also layer them up nicely. Watercolours are useful for getting lots of different shades and tones of a colour onto a page, and they're perfect for wax relief.

A large bottle of black Indian ink is also a staple in my kit, which I like using on brightly coloured paper, creating repeat patterns and strong, bold line work.

Wax pastels are fun to work into your pages with. They create super-rich pops of colour if you apply them over dried paint and you can use them to add pattern or details to illustration work.

Solid colour

Use a big brush to paint full pages of solid, rich colour in your favourite hues. Some can be used for backgrounds, while others can be cut into shapes to collage. Remember that the more water you add to your paint, the less opaque it will become.

Texture and pattern

Textures can be useful when you've got something particular in mind to recreate in collage. Sheets of dappled green, yellow and orange paint will work wonders for autumn leaves, watercolour washes with varying colour intensity will be great for making a seascape, and a stippled effect could make ideal animal fur. Lightly paint over sheets of newspaper to obscure the writing, but add even more texture.

Experiment with different brushes to create your textures. Wide brushes are good for creating big blocks of colour, but they are also useful for crosshatching if you pull the brush very lightly over the surface of your page horizontally and then vertically.

Top tip: Have some scrap pieces of paper around for getting excess paint off your brush. You'll build up additional pages of interesting textures this way.

Move your brushes around in different directions to get lots of interesting marks. I like being able to see the pattern of the brush. You can also add more layers of paint to your paper once the first colour has dried.

Patterned paper is fun to use in abstract collages where colour and shape are your focus. Add interest to your shapes by cutting them from papers with abstract brush marks, polka dots, wiggly lines or starbursts.

Drying and flattening your papers

Stick your painted pages to a window with washi tape to dry out. Flatten them under a big pile of heavy books overnight once the paint is dry.

Painted papers key

1. Orange gouache on red paper
2. Cross hatching made with paintbrush
3. Curved brush strokes made with white acrylic
4. Bold pattern made with Indian ink
5. Green paints applied over pattern made with a wax candle
6. Wax pastel stars
7. Green paint sponged on top of earthy base colour
8. Repeat pattern made with paintbrush head
9. Cloudy wash of white acrylic
10. Pattern made with cotton bud
11. Pink and red paint applied with a toothbrush
12. Wax crayon scribbles

Top tip: If you're using a scrap piece of card to mix your colours, keep hold of it. It could become the perfect base for a colourful collage.

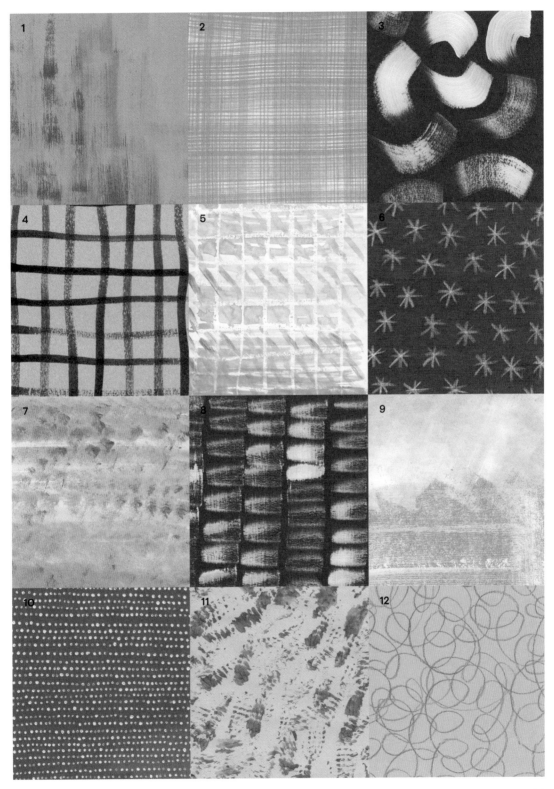

THOUGHTS, TIPS AND TRICKS BEFORE YOU BEGIN

Move the paper, not the scissors

The easiest way to cut an image smoothly is to slowly move the paper as your blades begin to close on the cut line. By rotating the image and cutting at the same time, you'll achieve a continuous, crisp edge.

Sharp blades

A craft knife loaded with a sharp blade makes all the difference. Your cut line will be clean and you'll slice through paper in no time. Avoid twisting your hand into tricky positions to make a cut. Instead, create small slices and rotate your paper for ease, moving the blade towards you, but always keeping away from the hand you're using to hold the paper steady.

Cut down pages to a manageable size

If you're cutting out an image from a magazine page or a small shape from a larger piece, roughly cut around it first to get rid of the excess. Holding a smaller section will make cutting much easier.

When you first cut out an image, leave in the shadows around it. It's easier to cut away than to add things back in, especially when it comes to people, where chopping off a feature can cost you the image.

Work from background to foreground

As a general rule when layering and gluing your collages, work from background to foreground. Get your largest images and areas down first and build upon them.

Embedding technique

Sometimes, you'll want to create seamless images constructed from disparate sources. The best way to embed images in a scene is to use your craft knife to cut around the outline within the main image, allowing the second one to be slipped in behind and integrated without visible cut lines.

Negative space

The empty space around an image is just as important as the image itself. It shares the edges of the object and can bring balance to a composition. Always think about negative space when you're working: does every inch of your paper need to be covered or could your elements benefit from space to breathe?

Edges

Always consider the type of line you want to create. Is it smooth or choppy? How will the edge style of the shapes change the overall feel of the piece you're making?

The other side

Always take a look at the other side of a magazine page before you start slicing it up. There might be something worth saving, or an even better image to take your scissors to.

Getting started

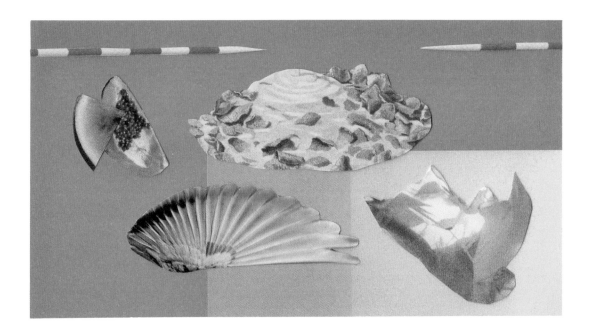

Good light

Avoid shadows being thrown across your page and obscuring your view. Work with good natural light, so you can see your work properly, and find yourself a good desk lamp or two.

Scrap paper for gluing

Always have a scrap piece of paper or card to do your gluing on so your table remains nice and clean.

Viewfinders

This is a useful tool to help focus your attention on a specific view. Use it to pinpoint a scene you want to collage or find the most interesting part of a picture. A simple frame can also help you crop your collages and determine how much negative space is needed around a composition.

Use a plain piece of paper and cut a square or rectangle from the centre to create your framing device.

Trial and error

What you don't see in the step-by-step projects in this book are all the steps that were taken before I got to the finished instructions. Sometimes, artworks will work first time, but often you'll need to try alternative colourways or placements or completely rethink an idea before you're happy. Trial and error is a big part of making work, so don't feel deflated if it takes a few tries to make the collage you see in your mind's eye.

Top tip: You can think of these collages as preliminary sketches, but this isn't to say they're not precious or should be thrown away. Often, the things I do speedily, with little intervention, become my favourite pieces.

Getting started

I often start a session in my studio with some spontaneous warm-up collages. These are compositions that are thrown together quickly to get in the zone, with little thought for perfection or meaning.

WARM-UPS

Although less daunting than a blank page you intend to disrupt with a pencil or paintbrush, a blank page is a blank page all the same. Setting a time constraint can be a brilliant way of loosening up and letting intuition guide the way. With little time to think, you get your most immediate ideas down and they're often the ones you'll come back to at a later date.

WARM-UP 1: TIME TRIALS

Instead of telling you exactly what to make, I'm going to give you a long list of possible themes (see page 28) and suggest that you approach them with short timeframes on the clock. Try three-, five- and ten-minute compositions, theming them to words on this list.

Don't feel as though you need to make something instantly recognizable. You might wish to utilize colour and texture and portray a mood or feeling rather than make a figurative collage. It doesn't matter if the final outcomes feel childlike,

as they're intended to be quick-fire reactions that can be built upon if you like their beginnings. Work relatively small to begin with and progress to larger sheets for expansive, mood-led compositions.

It's completely up to you what you use at this stage – magazines, colourful paper, whatever takes your fancy on any particular day. As these are quick and intended to be sketch-like, it might be worth saving your favourite images or a special paper swatch for a composition you're going to take more time over.

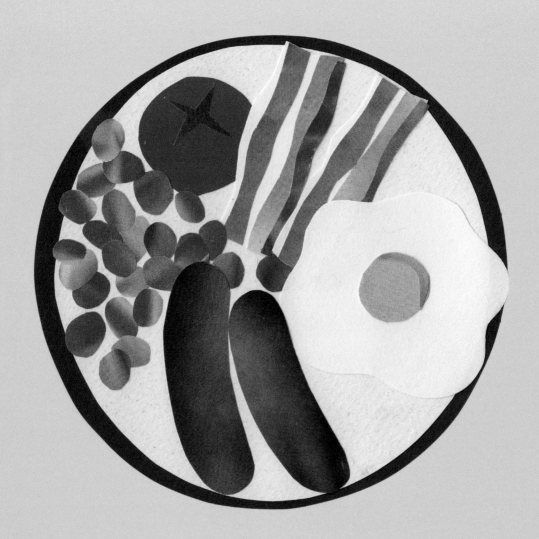

Possible themes

Some of the words are big and broad – more about translating a feeling onto the page. Others are places, spaces and things. Choose one of these themes each time you make a warm-up collage or pick your own if you have an interesting starter word in mind.

Under the sea	Morning	An imaginary
Space	Evening	vehicle
The jungle	Holidays	Tangled
Food	The weather	Fragmented
Nature	Your mood	Light
The circus	An animal	Heavy
Architecture	Colour	Chaos
A city	Water	Calm
Home	A portrait	Texture
The seasons	Fruit	Fireworks
A party	Birds	Deconstruction
Minibeasts	Vegetables	Music

Getting started

WARM-UP 2: TRANSFORMING SHAPES

Try turning a shape into as many things as possible. For example, a circle could become a…

Tomato
Wheel
Balloon
Pizza
Apple
Orange cut in
 half
Beach ball
Tennis ball
Basketball ball
Eyeball
Porthole

Breakfast plate
Planet
Lightbulb
Melon
Button
Fish pond
Petri dish
Bauble
Clock face
Human face
Centre of a flower
Road sign

Magnifying glass
Bird's-eye view of
 alphabet pasta
Coin
Doughnut
Ferris wheel
Globe
Kiwi half
Cog
Sushi roll
Bubbles

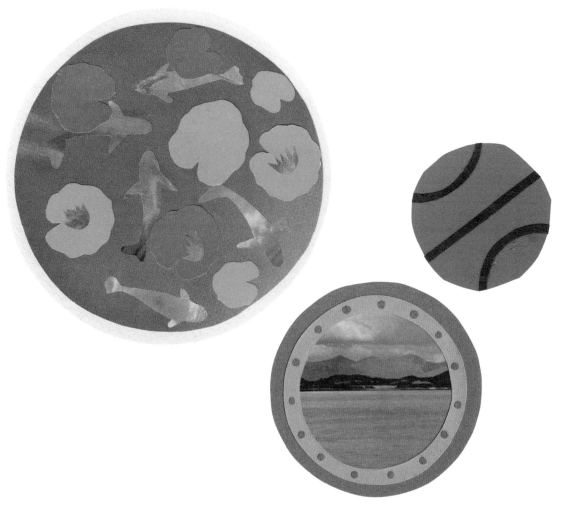

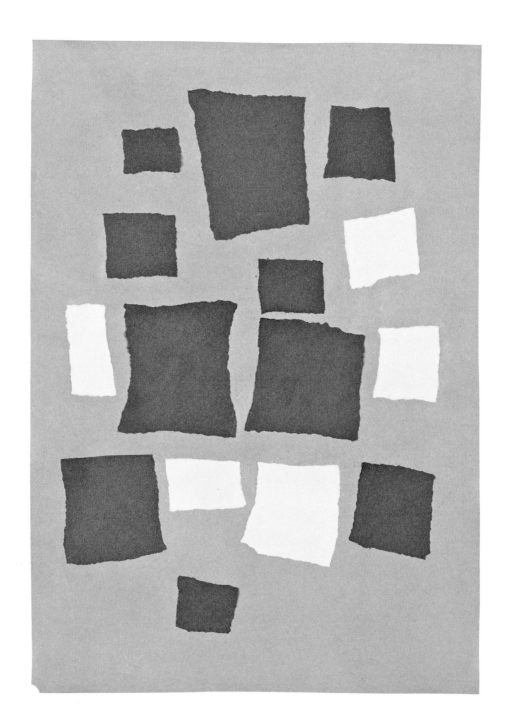

Jean Arp
Collage Arranged According to the Laws of Chance, 1916-17

Getting started

German-French artist Jean Arp (1886–1966) was a sculptor, poet and painter associated with the Dada movement. Alongside working with words and 3D forms, he was also known for his chance collages, a signature technique that saw him tearing paper into rough shapes and dropping them onto a large substrate without interfering with where they landed. Said to be feeling frustrated with a drawing he was working on, he pushed it to one side and let chance guide the way instead. This technique was a real game-changer in an art world that held artistic control and precision in high regard.

WARM-UP 3: COMPOSITIONS LED BY CHANCE

Although Arp's compositions were allegedly left completely to chance, I'm not sure he was able to relinquish full creative control, given the relatively ordered aesthetic of the squares on his page. I urge you, however, to let go if you possibly can and let gravity do the hard work. There's something incredibly liberating about leaving things up to chance sometimes. This is an exercise you can come back to whenever you need to, and doesn't need only to be seen as a warm-up. If something's not working well in a composition, let chance guide you.

Unlike Arp, who only used torn-edged squares, I suggest you use a selection of shapes. Consider a mix of soft shapes (circles, lozenges, wiggly-edged shapes, some with torn edges) alongside sharp ones (triangles, rectangles, pointy starbursts).

Materials
A3 (tabloid) substrate,
 although feel free to
 go bigger if space
 allows. Working small
 will be tricky, as
 elements might float
 off the page.
Various shapes cut from
 colourful paper or
 magazines
Scissors - or rip your
 shapes by hand. You'll
 have far less control
 creating a ripped
 line, which brings
 in a whole additional
 layer of chance.
Glue

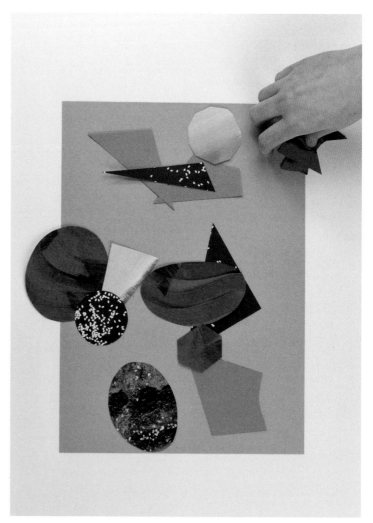

Getting started

- Cut out a selection of shapes in varying sizes. Cut more than you think you'll need and save the ones you don't end up using for a warm-up activity another day.

- You might prefer to stand up for this experiment to give yourself more space between you and the page. Let your shapes drop onto the base, starting with your largest ones first so as not to obscure smaller shapes. Unless they escape completely off the page, don't change where they land. Continue to drop shapes until you feel your composition is complete. Change how you view it – does it work better compositionally if you flip it 90 or 180 degrees?

- Take a photo of your composition for reference, then gather up your shapes and drop them again. Try making a few compositions this way. If and when you're particularly happy with a creation, commit to it with glue.

- Once you've made a few collages with zero interference, allow your eye to do a bit more of the work and bring a tiny bit of intervention into the mix if you feel it's needed – move or rotate a shape slightly to improve the balance of your composition. It can be encouraging to realize your creative eye will automatically direct the pieces of paper to land in specific places on the page.

Questions to ask yourself while making:

Is your composition abstract or are images appearing? Perhaps a landscape or a fragmented face?

Is the balance working?

What would bring more interest to the composition?

Is there too much negative space or not enough?

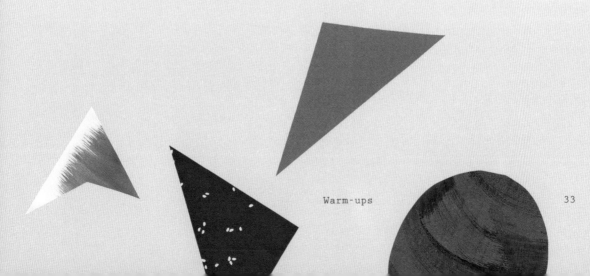

Warm-ups

I could write an entire book about how much I love scraps. The bits of paper leftover from a project are always loaded with creative possibilities. Often my favourite pieces of work are the ones I make quickly with slivers and fragments of discarded paper. Because these bits aren't in any way precious, you can be fast and free with your composition making and not worry about the results.

SCRAPS

Top tip: Use craft punches on any pieces of paper too small, gluey or scuffed to be reused. I call it collage confetti and it's great for shaped and pattern-based collages. Keep the cut-outs, too, for abstract works.

Get yourself a box that is solely for housing these remnants, and keep it on your desk so you can dip into it easily.

Use your offcuts to make warm-up collages informed by colour and shape, or within a quick exercise at the end of a making session to ensure every last piece on your table is utilized. Set yourself a two-minute timer and throw together a spontaneous, abstract composition. You can also supplement them with whole images that haven't found a home in your main collages.

I enjoy piecing together compositions on miniature sheets of 150gsm cotton-rag paper. The rugged edges complement them nicely.

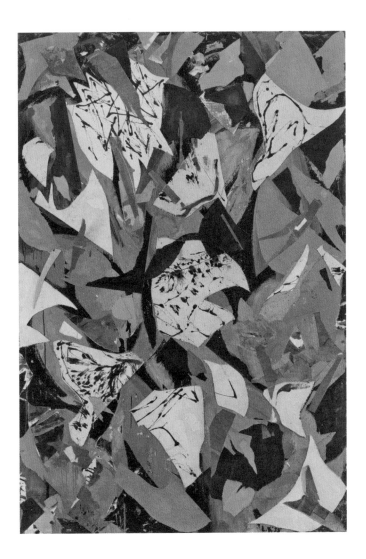

Lee Krasner
Bald Eagle, 1955

ARTIST SPOTLIGHT
Although primarily an abstract painter, American artist Lee Krasner (1908–84) developed a series of collage paintings during the 1950s using a fascinating technique. Having just wrapped a solo show where no work sold despite being well received, she returned to her studio and opted for a new approach, hoping it would guide her into a fresh way of working. On deciding she 'despised it all', she began tearing her drawings up, abandoning them on the studio floor until she returned a few weeks later and realized there was actually lots of potential in the shreds she'd thought destined for the bin.

These fragments became the starting point for a series of collages Krasner made, layered over those canvases that didn't sell. She also added bits of hessian, newspaper, photographic paper and some of her husband Jackson Pollock's discarded drawings. The works started small with organic palettes and developed into large-scale, graphic works with lashings of bright colour.

PAPER-CUT COLLAGE

This section is dedicated to making collages using paper: colourful, textured and patterned pieces, without the addition of photographs or found imagery. You'll use your scissors as a drawing tool to cut beautiful shapes from the painted papers you've prepared, and develop your own unique style while doing so.

Starting with the fundamentals of colour and shape, you'll create lots of mini abstracts, before dabbling with high-contrast compositions and ways to make patterns that pop. This section will also cover how collage can be incorporated into illustrative projects and give you the confidence to snip scenes and spot illustrations personal to you. There are no limits to what you can make with this joyful technique!

If you're new to collage, experimenting with colour and shape is a good place to start. They are the foundations for much of the work within these pages, so we'll begin by using them as building blocks in their simplest form.

COLOUR AND SHAPE

Although some knowledge of the colours that work well together is useful, it's also important to let your colour decisions be led by mood, feeling and, ultimately, personal taste. Choose the colours that speak to you on a particular day, or ones that reflect your mood while you're collaging. There are plenty of resources that can teach you all about colour theory, but here you only really need to know the basics and your favourites.

If you're ever feeling stuck, refer back to the colour wheel or pick a combination you'd never normally use. If you're feeling blue, pick the brightest colours available to you.

Paper-cut collage

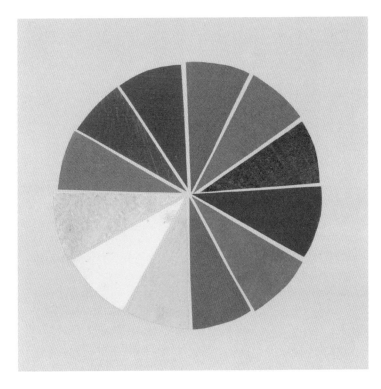

If you were to draw a line down the centre of the wheel, you'd find a split between the warm (reds, oranges and yellows) and cool (greens, blues and purples) colours. This can be useful when trying to convey a certain atmosphere, time or place within your work.

Play around with colour swatches and look closely at how they're affected when placed next to each other. Take note from colour combinations from the world around you – a pairing from your wardrobe or the colour of a sun-lit building against a bright blue sky, for example. Keep a notebook handy and jot down colour sequences you're drawn to. Use them to inspire and inform!

Colour wheel

Here is a basic colour wheel. It consists of the three primary colours (red, yellow and blue), the secondary colours, which are colours created when primary colours are mixed (green, orange and purple), and the tertiary colours, which are made when a primary and secondary colour are mixed (amber, violet etc.). Colours opposite each other on the wheel are known as complementary colours and will make the other pop brightly. If a high-contrast pairing is needed, the combinations below will work wonders:

Purple and yellow

Blue and orange

Red and green

Primary colours and geometric shapes

This is less a step-by-step guide and more a snapshot of how you might approach compositions led solely by colour and shape. Here I've documented the ever-changing state of a collage while I'm working on it, finding the right place for each piece. For this experiment, I've used a primary palette and a range of mainly geometric shapes, which might be a nice way for you to start, too.

Approach these initial compositions as you would a puzzle – search out the space each element fits best. Throughout the process, ask yourself: is the balance working? Does the composition feel too busy or too empty? Are the colours working? Should the edges sit flush or overlap?

Materials
A selection of coloured
 paper - plain,
 patterned, textured
Scissors
Blu Tack (reusable
 adhesive) to secure
 elements in place
 while working
Glue

1. I start with three large shapes with their edges flush to each other.

2. I shift the red element up slightly, so I can slide a blue shape between the yellow to really make it pop. I also snip a circle in half and play with how the edges of these elements interact with the other shapes.

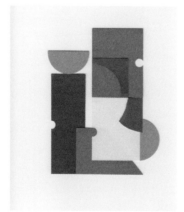

3. This red rectangle and blue semicircle look like the beginnings of a column, so I bring them down to the base of the collage. Everything feels a little rigid, so I add some curved shapes and a torn, red edge.

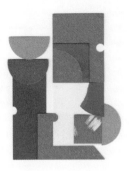

4. I add another semicircle in a darker blue. I also bring in another blue tone – this time a painted paper square. The texture brings interest.

5. I extend the blue tower, but it's a little top-heavy now. Another pop of yellow is brought in on the left side of the collage to lift it.

6. The top-left corner isn't working as harmoniously as the rest of the collage, so I focus my attention here.

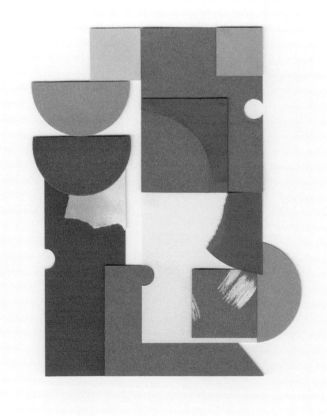

7. I return to two upturned semicircles and level off the top edge with a orange square that mirrors the blue one further down.

8. One final turquoise touch in the top right corner pulls the collage together.

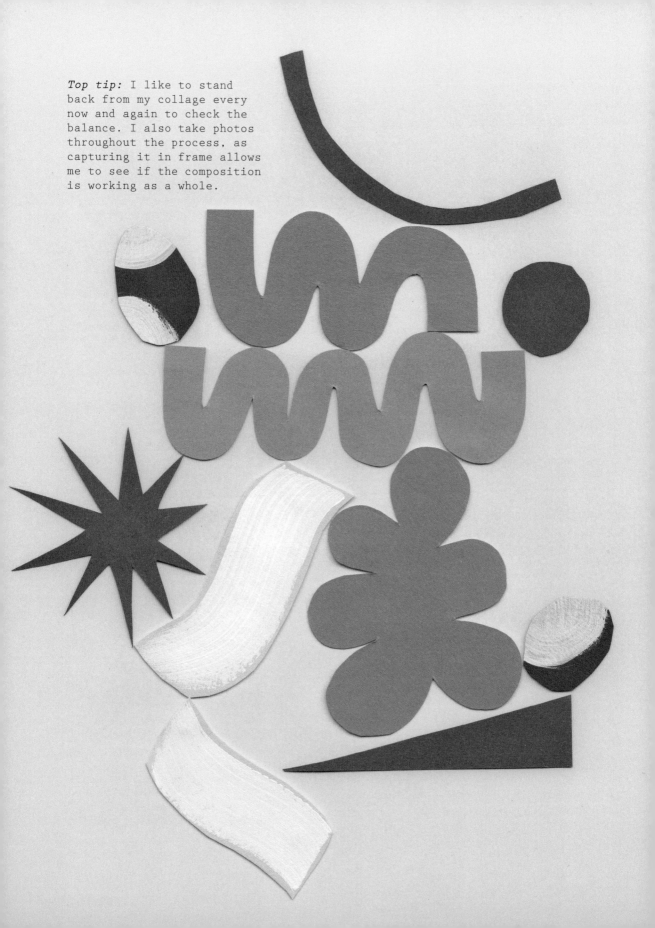

Organic shapes

Once you've experimented with crisp-edged geometric shapes, try working with organic, freewheeling ones.

Here the same shapes have been used across six compositions, showing just a slice of the infinite ways they can be pieced together. As well as using a white substrate, try using different colours – how does this change the feel of your composition? Do colours shine vibrantly against a specific background?

This is just one of a million ways those shapes could be placed. Experiment with your own placement and enjoy the breadth of possibilities in front of you. Make lots of different compositions and consider what you like best about your favourites.

MORE VARIATIONS

Repeat shapes

Are there shapes you can repeat throughout your collage to pull it together? In this collage left, tiny dots are placed in the bottom-left corner of a shape each time.

Stacking shapes

I often envisage my two-dimensional elements as three-dimensional structures. Imagine what your paper forms would look like towering upwards in the real world. Would they stand up straight or topple over?

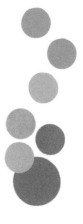

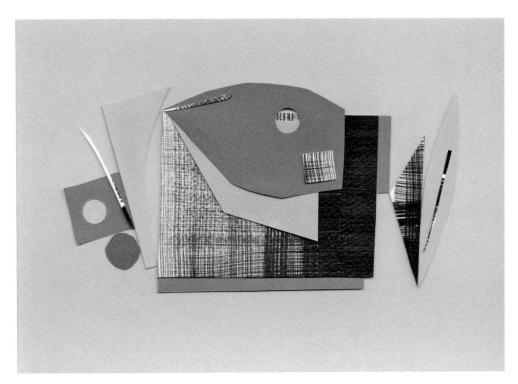

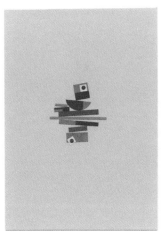

Muted tones

Colour doesn't always need to mean bright and dazzling. Try using muted, sophisticated combinations, and don't be afraid to add textured areas too.

WORK LIKE KANDINSKY

Wassily Kandinsky (1866–1944) was a Russian painter and art theorist, considered one of the pioneers of abstraction in Western art during the 20th century. He approached painting with a focus on colour and shape rather than striving to create recognizable scenes, often drawing from his imagination or creating work inspired by a feeling using reduced forms.

Kandinsky is believed to have had synaesthesia, a condition that meant his senses were blurred, allowing him to tell what a certain colour felt and sounded like and whether it was hot or cold.

Think about how you experience colours and the shapes and sounds you identify them with. For me, blue feels like a circle with a calming, steady melody, while yellow is a spikier shape, and high-pitched in tone.

Try creating a collage using the colour and shapes you pair together in your mind. You could listen to your favourite song and express the colour and shapes you feel best represent it.

Having formed compositions that comprise your favourite shapes or mirror the ones in the previous experiments, now try using shapes from real life as a starting point. Abstract works are often derived from and informed by a specific time, place or memory. They capture the essence of something or somewhere without trying to represent it accurately as the eye would see it.

CREATING AN ABSTRACT COLLAGE, INSPIRED BY TIME, PLACE AND MEMORY

Use what's in front of you to come up with the shapes for your abstract composition. It could be a snapshot of your desk, a landscape, the view from your window or a still life. Break down what you can see into basic components, reducing shapes to their simplest forms: buildings can become rectangles, cars turn to squares, and trees to upturned triangles. Create uncomplicated pencil sketches and use them to inform the shapes you cut out.

Grounding your compositions in reality can give them meaning, even if they no longer resemble real life. Feelings can also be a good starting point for abstract creation.

ARTIST SPOTLIGHT

Henri Matisse's (1869–1954) paper cut-outs were pioneering when he began making them in the 1940s and have remained a source of inspiration for many in the decades that have followed, thanks to their innovative use of colour and shape. When the French artist became ill in later life, he was no longer able to paint, so he swapped his brushes for scissors and began cutting vast sheets of richly coloured, painted paper to make sketches for his commissions. This soon became his primary technique for creating large-scale cut-outs of dancing figures, plants, swooping birds and works inspired by memories of places he'd visited. He referred to this method as 'drawing with scissors'. Much of his work was pinned to his studio walls, which meant pieces could be composed, reworked and remain in a state of flux while Matisse and his assistants worked on them.

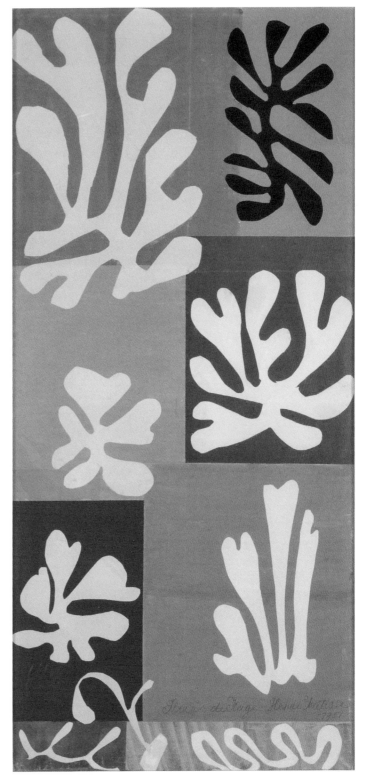

Henri Matisse
Snow Flowers, 1951

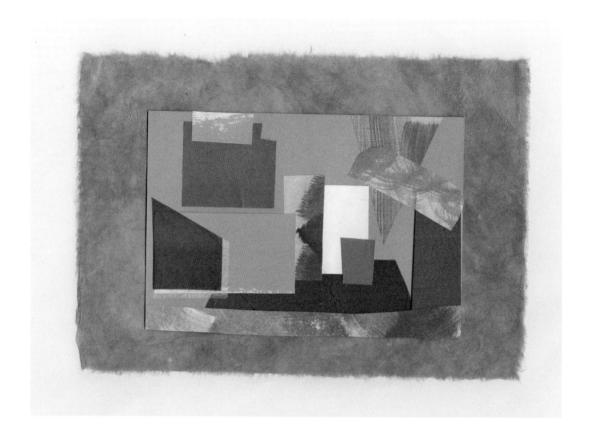

My abstract desk (above)

Summer memories (opposite)
Some works you make could take a more personal approach and serve as a reflection of an emotion or memory. I had a fun summer holiday in my mind while creating this abstract work. I also wanted to represent the wonderful sensation of closing my eyes on a hot, sunny day and seeing colours and shapes dancing across my eyelids. To achieve the intensity of colour I was after, I worked back into the collage with high-pigment colouring pencils to give it extra depth. A viewer might read the piece in a completely different way and that's okay. Abstract works are open to interpretation!

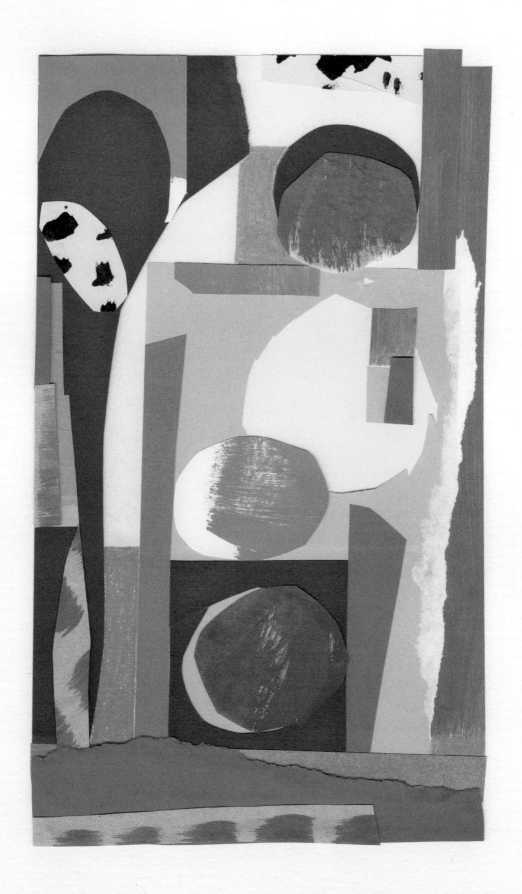

Benode Behari Mukherjee
Untitled, 1959

Project idea: Try
creating a series of
abstract collages
informed by the
seasons. What colours
and shapes best
represent spring,
summer, autumn
and winter to you?
They can be general
(orange and red
tones of autumnal
leaves) or guided
by something very
specific to you.

Other compositions you
make could be recognizable
like the simple summertime
vista opposite. Here a sunset
has been broken down into
sun, sea and sand, using
brightly painted paper.
The image is instantly
recognizable, despite being
represented as a series
of simple shapes. The
emphasis is on colour and the
juxtaposition of smooth cuts
against ripped edges.

Paper-cut collage

Working from a still life gives you the opportunity to study colour and shape up close. Gather a selection of objects from around the house and arrange them in a way that excites the eye. Pick things traditionally found in still-life set-ups such as fruit and flowers and pair them with interesting objects that range in height and size.

STILL LIFE

If you don't feel confident going straight into collaging, feel free to create a pencil sketch first. This will help you look closely at the shapes and how they interact and overlap with each other. If you're particularly happy with your drawing, use tracing paper to duplicate it and recreate your shapes with colourful paper. If your preliminary sketch is small, photocopy it and increase it to a workable size.

Use the still life as subject matter to create lots of outcomes, ranging from realistic representations to abstract artworks. You could make Cubist-inspired works, use a mosaic technique or use flat, bright colour.

Top tip: For symmetrical shapes such as bottles, fold your paper and draw or directly cut one half of the shape along the folded edge.

Paper-cut collage

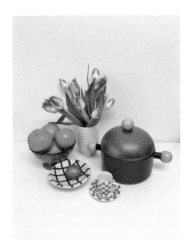
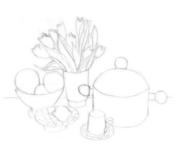
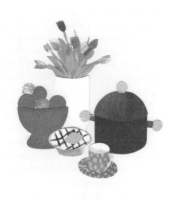

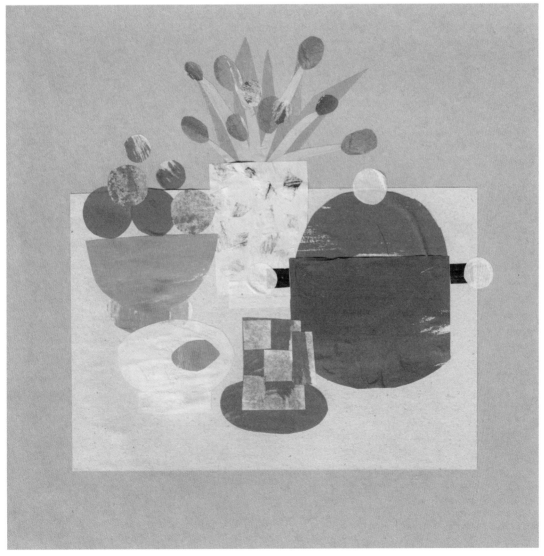

54

Paper-cut collage

Now that we've experimented with colour and shape, we can build on what we know works well together and have some fun with pattern making. We'll create repeat decorative patterns and free-form patterns that don't conform to a regular structure.

PATTERN

While you make, think about how your designs could evolve into something bigger. How would they look applied to fabric or turned into a large-scale print? Create patterns you'd like to wear yourself.

Geometric pattern

Geometric patterns can be fun to make, but repetitive if you're trying to fill a large surface area. Instead, try making lots of small pattern swatches within the same piece to bring more variety to your collage. The parts you particularly like can then inform collages you work on at a later date.

Starter words for your mini swatches:

Stripes
Zigzags
Wiggles
Circles
Half moons
Stars
Blocks
Triangles

For this floral pattern, we are going to use the secondary colours we know work well together. The same shapes are repeated the whole way across the page and you can imagine the pattern continuing way beyond the edges of the paper. It could make a great textile design.

FLOWER PATTERN

Materials
A4 (letter) neutral-
 coloured substrate
Lilac paint
Paintbrush
Painted papers -
 white, sage green,
 lime green, bright
 orange, purple
Scissors or craft knife
 and cutting mat
Glue
Pencil (optional)

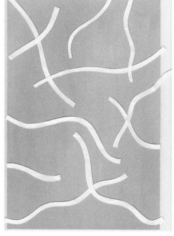

1. Start by painting your base sheet with a layer of lilac paint. Allow some parts to show the colour below while other parts become fully opaque. This will give you a nice texture to build upon.

2. Using your white-painted paper, cut wiggly strands and layer them onto the page to form an irregular pattern. Some can criss-cross while others remain isolated. Stick them down when you're happy with the positioning.

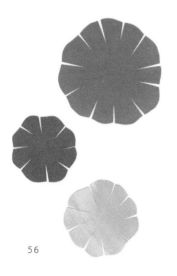

Paper-cut collage

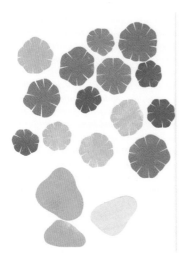

4. Layer your blobby shapes and green flowers onto your page first. Allow some to overlap and cluster together.

3. Now cut the rest of your shapes. From the sage-green paper, cut three or four blob-like shapes. Cut flowers from the lime-green, bright-orange and purple papers. Start with an irregular circular shape (cut freehand or draw out the shape on the back of your paper), then make thin triangular cuts each time the wobbly line of your flower dips inwards. Make a variety of sizes in all three colours and enough to fill your page.

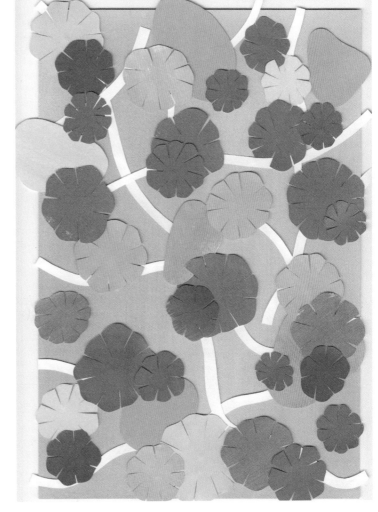

5. Add your orange and purple flowers and stick everything down when you're happy.

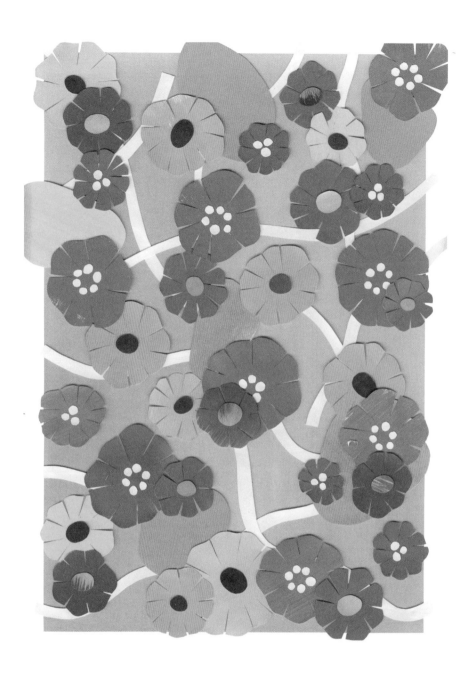

6. To finish off your flowers, cut contrasting centres for them. Use small ovals of purple paper for your green flowers and a lighter lilac for the purple ones. Cut tiny dots of white paper for the orange blooms. Use a paintbrush and liquid glue to stick these little pieces in place, as they can be a bit fiddly.

Geometric base pattern

Make a checkerboard base using squares of painted paper layered with contrasting triangles. Use it as a background to experiment with lots of different additions. Here I've layered leaves and fireworks to create an autumnal piece. You could make a pattern for each season. Use wax pastels for the leaf lines and black ink to paint firework starbursts.

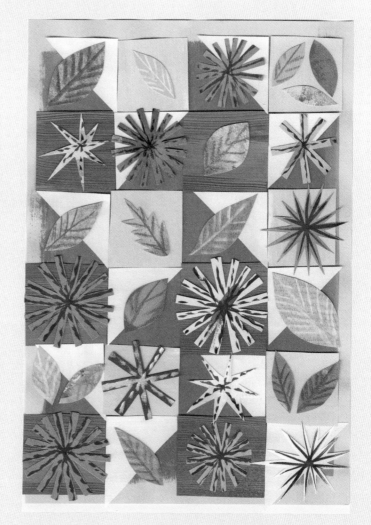

Materials
A4 (letter) black
 substrate
Painted and patterned
 papers
Scissors or craft knife
 and cutting mat
Blu Tack (reusable
 adhesive)
Glue
Pencil

This piece is loosely inspired by the beautiful patterns that can be seen when sand is viewed under a microscope. I created my shapes based on a memory of an image I'd seen in a magazine, so my design doesn't look much like the real thing, but I don't mind at all. Sometimes, inspiration can come from something as small as a grain as sand, and you can let your mind transform it into something wildly different. Creative licence is encouraged.

FREE-FORM PATTERN

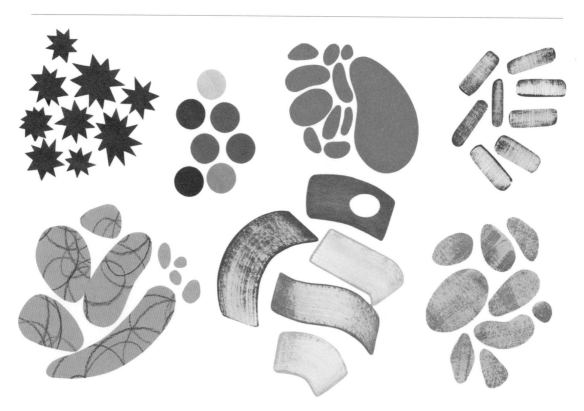

1. Cut out a range of shapes in different sizes. You can use similar colours to the ones pictured or choose your own palette. Use a pencil to roughly draw out your starbursts, remembering to flip them before sticking to hide pencil marks. Cut the rest of your shapes by eye using curved lines. Leave a thin outline of colour around your paintbrush strokes when you cut them out.

2. Place your larger shapes on the page with Blu Tack. Space them in an irregular way – some close together, others further apart.

3. Next add your medium-sized shapes. Nestle them in with the larger ones, always leaving a couple of millimetres of space between each one. Look for curves that complement each other and can be bundled together in a satisfying way.

4. Add more shapes to your pattern, making sure it feels balanced, but not too uniform. Allow some of your shapes to spill off the edge of your base paper. You can trim them down at the end.

5. Once the majority of your page has been covered, fill in the gaps with mini shapes and tweak any parts that need adjusting.

6. Remove the Blu Tack and glue each piece down.

Top tip: Patterns like this work well on a black base, as the colours pop.

Circus variation

Here I wanted to create a structured and symmetrical pattern. I was thinking about circus performers balancing on tightropes and a tent full of colour and festivity. I marked a faint anchor line in pencil down the centre of my page and worked outwards from there, placing shapes equally on either side and cutting some in half. I used stickers layered on top for a cheerful touch.

Circus is always a great theme, but you can use any word as a starting point. How about weather (spiky lightning bolts, fluffy clouds and teardrops of rain) or architecture (church spires, domes and towers of balancing bricks)?

1.

2.

3.

4.

Paper-cut collage

This project is a simple way to think about contrast within your compositions and experiment with negative space. Beginning with a black-and-white design will mean your focus is solely on the contrast between light and dark elements. Colour, pattern and texture are removed from the equation.

CONTRAST

Materials
A4 (letter) white-card
 substrate
Black paper (A5 (half
 letter) or slightly
 smaller)
Craft knife and cutting
 mat
Scissors
Glue
Eraser
Small hole punch

Remember to use a sharp blade for crisp edges: high-contrast compositions benefit from razor-sharp line work. Begin by deciding on the shapes you're going to use. Copy the ones used here or sketch out your own before you start. Consider using a mix of shapes with soft and sharp edges.

1. Use a pencil to map out your first shapes on the back of your black paper. Start with three or so whole shapes dotted across your paper and use your craft knife to cut them out. Keep all the shapes you cut out, as they will be reworked into the collage a little later on. Neaten up your edges with scissors if need be, but try to keep the negative and positive cuts as identical as possible.

2. Bring in your second motif. These can be half shapes at the edge of your piece of paper. I've used coral-like forms, as this type of shape looks brilliant when the matching cut-out is placed beside it.

3. Continue to build up your paper with cut-outs. Think about the balance of your composition and where new shapes will interact well with your existing cutaways. I've opted for a full starburst in the centre and a half star at the edge of my paper.

4. Take a step back to check the harmony of your design. I decided to add a semicircle to the untouched top edge here. Avoid cramming too many shapes onto your composition and instead give your elements space to breathe. When you're happy, glue the black paper to the centre of your white base, remembering to flip it over so your pencil lines don't show.

5. You can now start adding in the cut-out elements you've kept. Half-shape positives can be placed next to their matching negative cut-out, while whole shapes cut from the middle of your paper can be placed wherever catches your eye. Try them out in different places before committing to your placement with glue, and use an eraser to get rid of pencil lines if your design requires you to use them mark side up. Here there is an interesting interaction between the starburst points and the curve of the semicircle edge.

6. Use a small hole punch on some of your shapes. Keep the tiny circles and use them to finish off your composition. Cut out a few white circles with your hole punch, too, and place them on the black paper. Bringing in different scales like this will add interest to your composition.

Top tip: Notan is a Japanese design term that means 'light and dark harmony'. What you have just created is a great example of this concept.

Paper-cut collage

More experiments

Once you've made a number of black-and-white versions, try experimenting with high-contrast colours. Play with combinations such as yellow and purple, which sit opposite each other on the colour wheel, or try out a combination of different tones – baby blue and a rich midnight hue, for example.

Alternatively, stick with black as a core tone and try it with a range of other colours.

This red and pink design (left) could make a striking repeat-pattern print for fabric. It's full of energy and movement, with the irregular points of the stars adding to this impression.

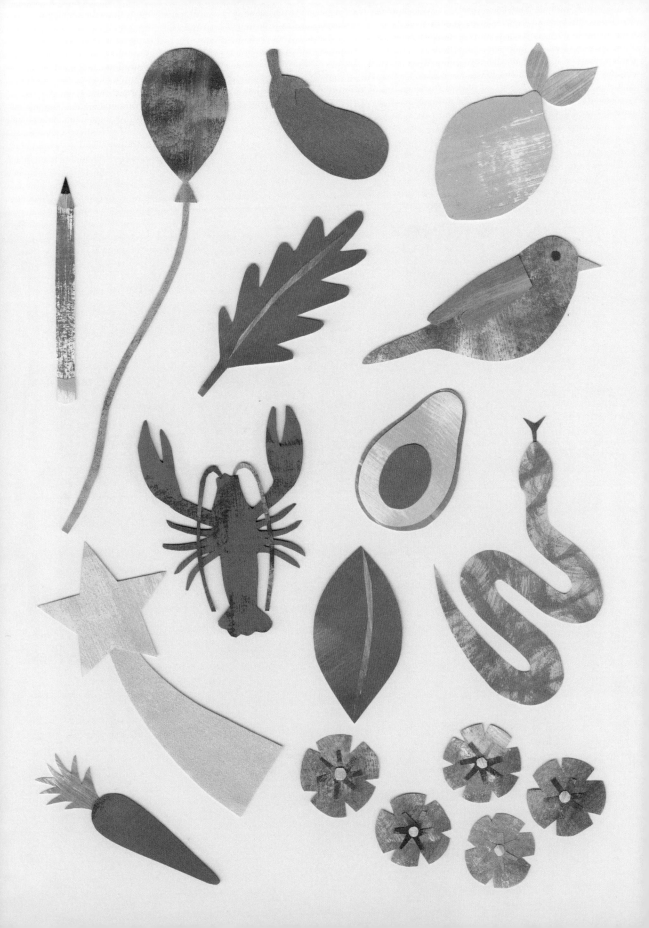

This section will introduce you to collage as a technique for creating illustrations. It will guide you through simpler projects that involve snipping single images and collections of objects, before moving on to building up full-page scenes brought to life with painted paper.

ILLUSTRATION

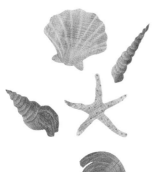

These single-cut shapes have detail added with white and brown wax pastels.

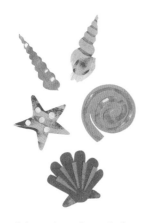

Bold and colourful, these shells have a graphic quality to them.

Please don't think you need to be great at drawing to create this kind of work. Often you only need a simple outline to make something recognizable and I personally love illustrations that have an uncomplicated aesthetic. They're charming and characterful. There's also no need to rely on memory – use reference imagery from the internet, books and photographs to help you match shapes and colours.

Children's books are a brilliant place to look to for inspiration for illustrative collage, as they often use this technique within their pages. The likes of Eric Carle and Lois Ehlert might spring to mind when thinking of authors and illustrators you've seen on bookshelves, but there's a whole wave of contemporary illustrators using this technique, too. Some of my favourites include Christian Robinson, Oge Mora and Andrea D'Aquino.

Perhaps you have an idea for a story bubbling away and want to illustrate it yourself, or you'd like to make a personalized birthday card for a friend. This technique is ideal for projects both little and large. Try experimenting with lots of different styles to get a feel for how you like working best. Approach some illustrations with a bold, stylistic look and make others more true to life by using a familiar palette.

Illustration 69

Constructing an illustrated alphabet gives you the opportunity to make lots of mini collages. It's a nice way to develop your style of illustration and it will also give you freedom to experiment with lots of subject matter within one piece. Recreate the things I've collaged or come up with your own objects. Collage them onto one large substrate and add hand-cut letters or make them individually and scan them to make a digital composition.

ILLUSTRATED ALPHABET

Materials
Neutral A2 (16.5 x 23.4in) substrate (if you don't want a large final collage, scan each illustration and digitally reduce the scale to fit a smaller sheet)
Painted papers in a variety of colours and textures
Wax pastels
Scissors or craft knife and cutting mat
Glue
Paper tweezers
Blu Tack (reusable adhesive)

Go freehand or use a pencil to lightly map out the shapes you're going to cut on the back of your paper. I do a little of both, sketching out trickier shapes or ones that require more detail.

Before you get started, have a think about the overall aesthetic of your alphabet and the style of cut you make with your scissors. Are your edges clean and crisp or do they have a rougher, spontaneous feel to them? A subtle difference in the line your scissors make can totally change the feel of a collage.

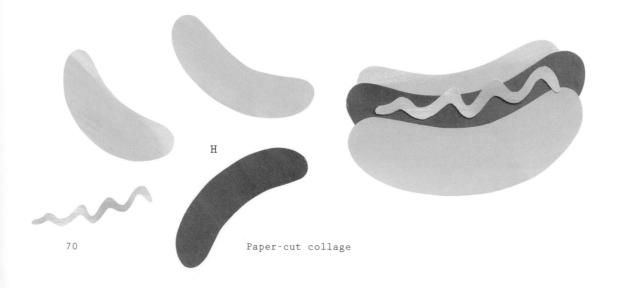

H

Paper-cut collage

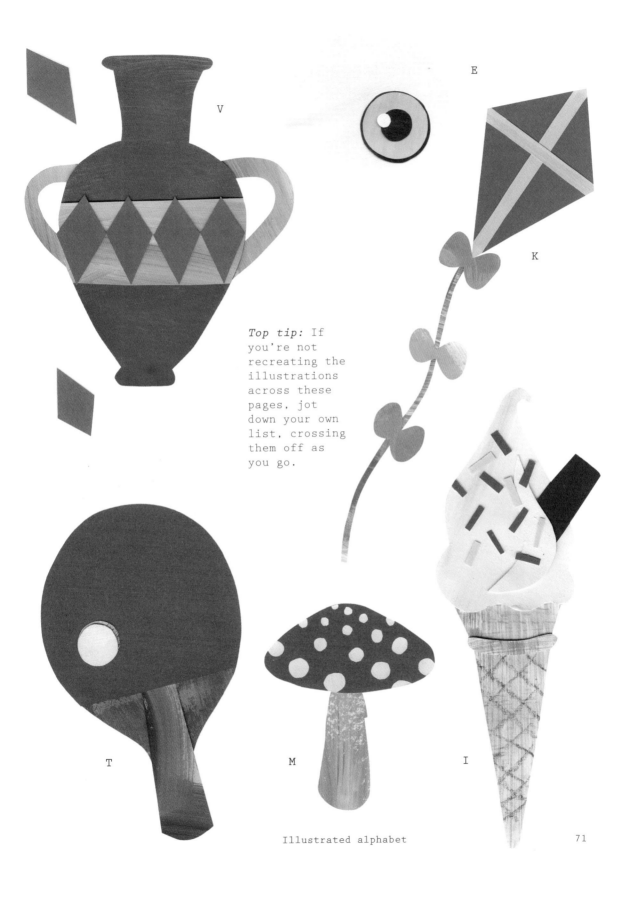

V

E

K

Top tip: If you're not recreating the illustrations across these pages, jot down your own list, crossing them off as you go.

T

M

I

Illustrated alphabet

Consistency

Use a number of the same colours throughout your alphabet to pull it together. Notice the cake, jelly and yacht sail are all cut from the same pink paper, for example. The dog and zebra have matching eyes too. Simple tricks like this will help you build a coherent style of your own.

C

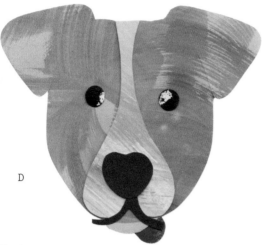

D

X

Texture

Pinpoint areas of your painted sheets that have great textures. Visible brushstrokes make perfect fur for this pooch.

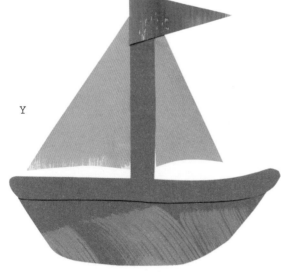

Y

C

Paper-cut collage

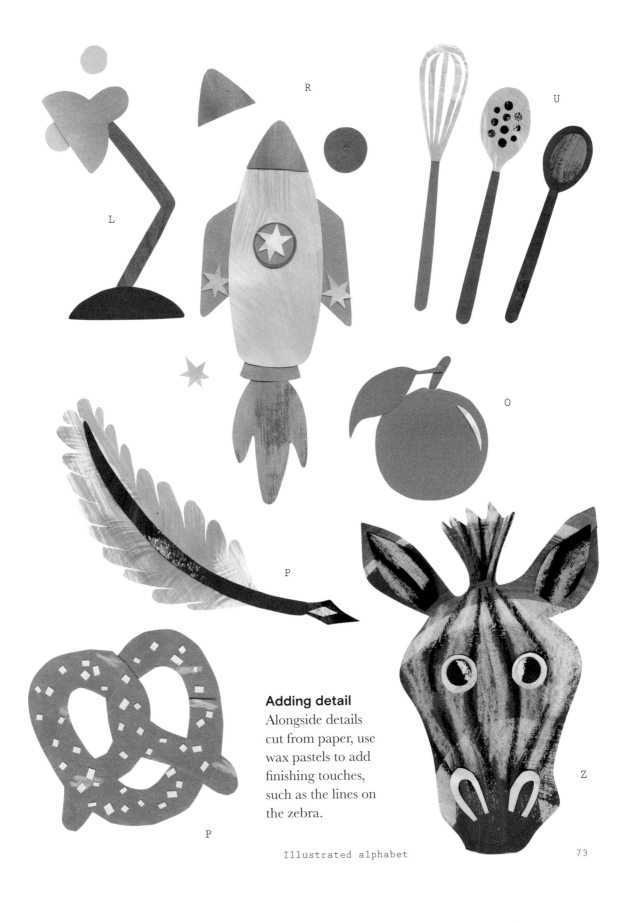

L

R

U

O

P

Adding detail
Alongside details
cut from paper, use
wax pastels to add
finishing touches,
such as the lines on
the zebra.

Z

P

Illustrated alphabet

Now you've cracked individual illustrations, you can begin piecing multiple elements together to form curated collections. Mini works like this are great when you've got a specific person in mind – giving a personalized collage as a present is a lovely way to show you care.

COLLECTIONS

Possible themes
 Cake ingredients
 Gardening tools
 Insects
 Books
 Shells and pebbles
 Favourite flowers
 Pots and vases

Consider the person's hobbies and interests and try recreating the associated objects in paper. It could be a selection of office supplies for a stationery-obsessed friend or houseplants for a green-fingered relative. The examples here are small in scale, but work bigger to allow for more detail if you desire.

 Use sheets of painted paper for your shapes and a neutral substrate. Here I've used some lovely sheets of recycled paper to add interest.

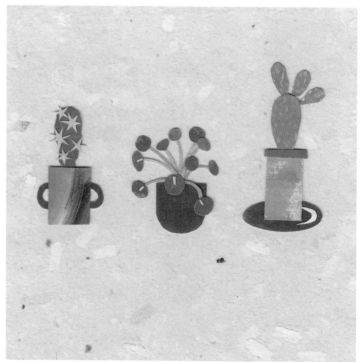

Paper-cut collage

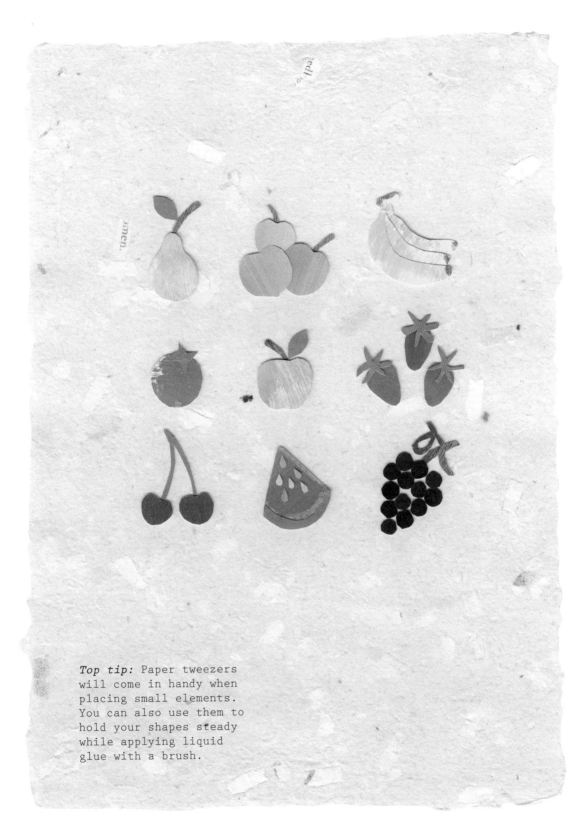

Top tip: Paper tweezers
will come in handy when
placing small elements.
You can also use them to
hold your shapes steady
while applying liquid
glue with a brush.

This scene is inspired by the run of shops by my studio. Sat below a row of flats with big windows and across from a park, the area has everything I could possibly need.

A DETAILED SCENE

Materials
A3 (tabloid) white
 substrate
Blue paint and
 paintbrush
Painted papers
Scissors or craft knife
 and cutting mat
Glue
Paper tweezers
White wax pastel
Small snippets of
 greenery from
 magazines

Once you've followed this step-by-step, try recreating a pocket of your own neighbourhood in cut-and-paste form. Use creative licence and emphasize the bits you like best in any given view.

1. Paint your substrate blue, leaving the edges rough and allowing the brush marks to remain visible.

2. While your paper dries, cut your building elements. Use a white wax pastel to add detail. The lighter, speckled windows are cut from a sheet made using the wax-relief technique.

3. Next, make the shops. Back them onto a piece of the same brown paper so you can move them easily as one, instead of four individual pieces.

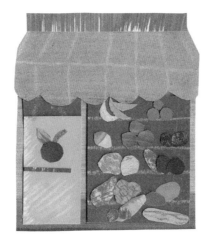

5. Create a pavement and road, by placing white road markings on top of the darker section.

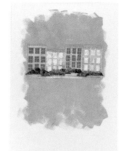
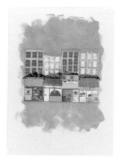
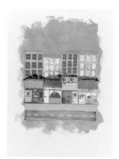

6. Work from top to bottom as you place your elements onto your substrate, starting with the windowed buildings and greenery. Then, for the foreground, layer up a selection of green mounds in different shades with strips of spiky grass poking out between them. Place them in a slightly curved formation.

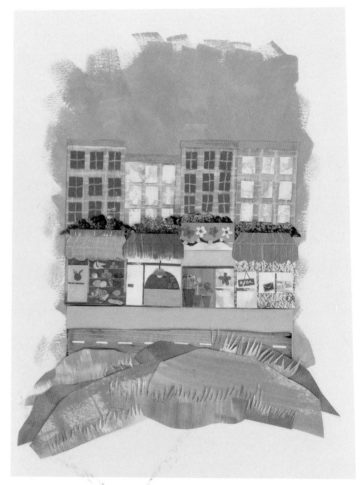

7. Trees, humans and birds can be placed to complete your artwork.

Paper-cut collage

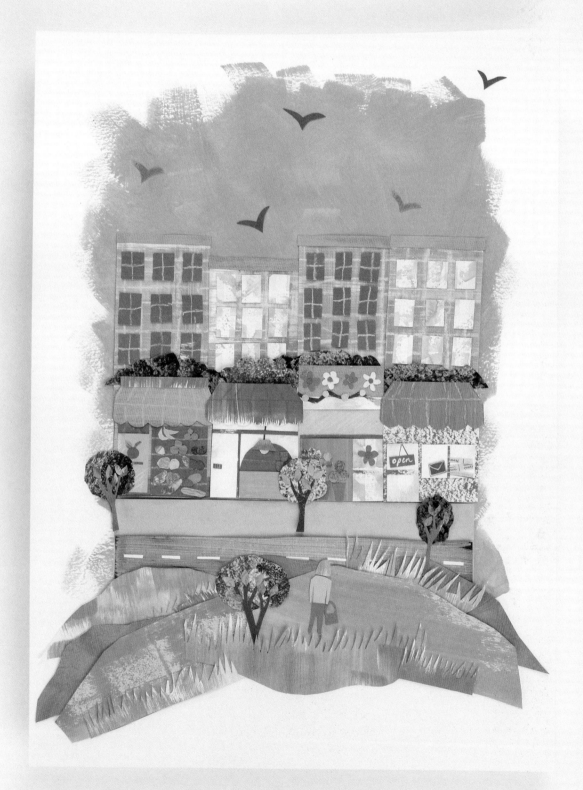

Let's make something bright and bold! This scene captures the busyness of the underwater world, with schools of fish darting this way and that. Although there's lots going on, the use of a simple viewfinder to frame the picture means it doesn't feel chaotic and draws the eye in.

BOLD AND BEAUTIFUL

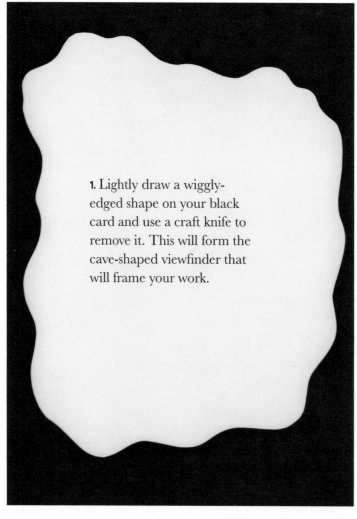

1. Lightly draw a wiggly-edged shape on your black card and use a craft knife to remove it. This will form the cave-shaped viewfinder that will frame your work.

Materials
A4 (letter) black card
 substrate
A4 (letter) dark blue
 card
Painted papers
Scissors
Craft knife and cutting
 mat
Pencil
Glue
Small hole punch
Paper tweezers

2. Cut out a variety of fish and coral shapes. Go for unfussy silhouettes in fun colours and make lots of tiny ones with a very basic outline, too.

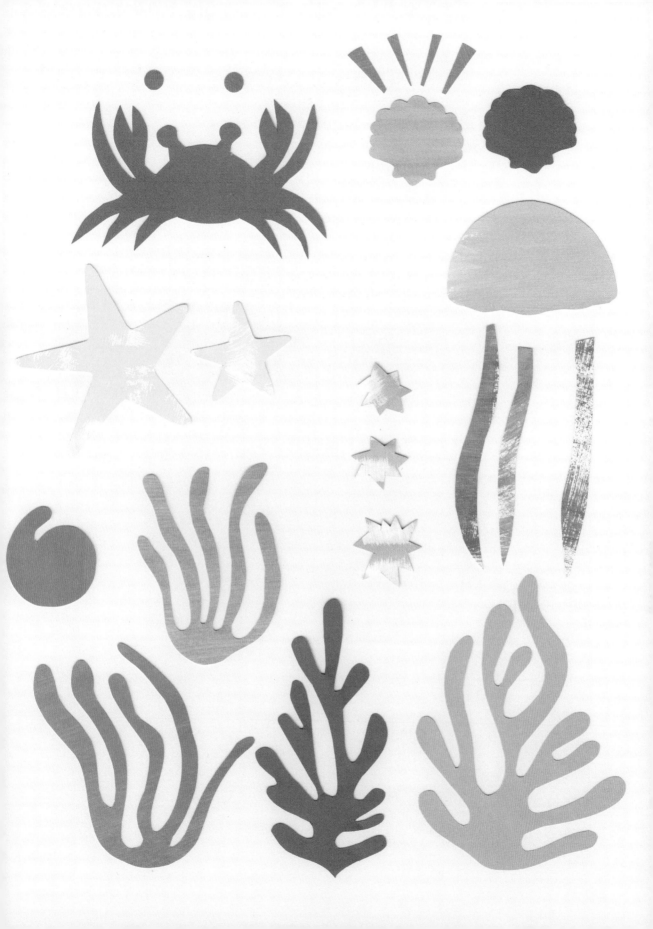

3. Place the dark blue card behind the cut-out shape. Arrange the shapes in groups and at different angles to each other to bring movement to your piece. Lightly place your viewfinder to check everything is working. With your viewfinder still in place, add your coral shapes to form a reef. Add a couple of shells and starfish, letting everything overlap and intertwine like it would on the seabed.

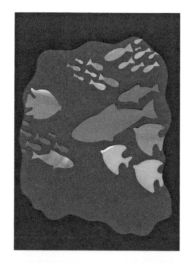 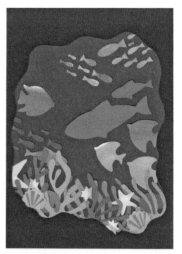

4. Cut a jellyfish and crab and add these to the foreground, layering them over the edge of the cave outline, moving them until the angles feel right.

5. Finally, add some small details. Make bubbles and fish eyes with your hole punch and add an extra fish or two if the composition requires it.

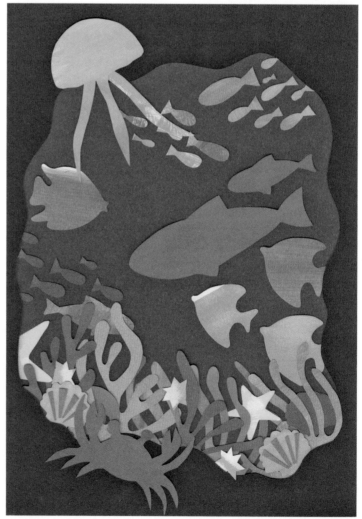

WORK LIKE EHLERT
Take a look at the work of Lois Ehlert (1934–2021), an American author and illustrator who created children's books bursting with educational, collaged illustrations. She was a pro at using colour and shape to communicate big ideas.

Paper-cut collage

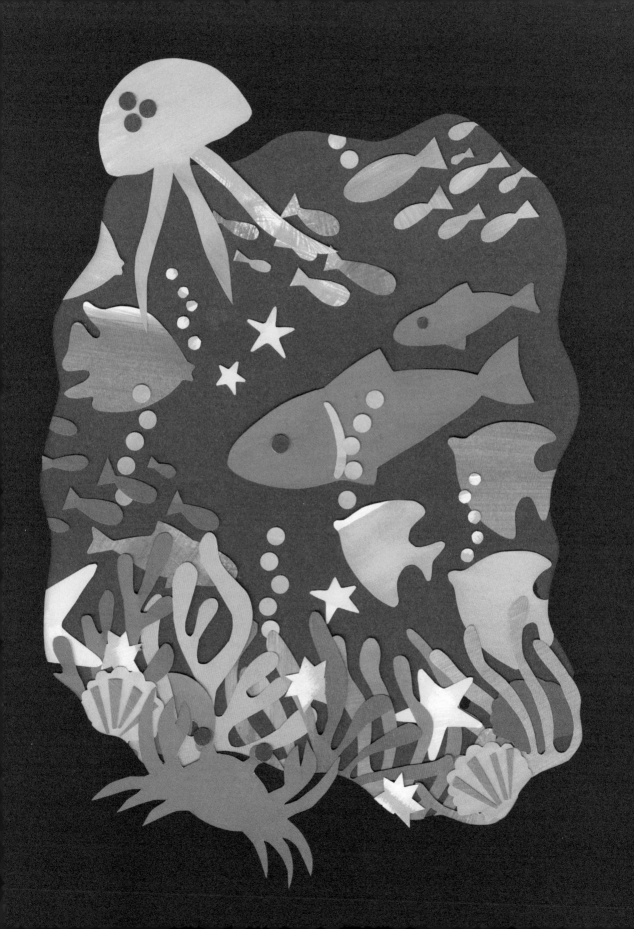

FOUND IMAGERY

Now you've got to grips with paper-cut collage, it's time to have a go with found material. For the most part, this means imagery sourced from magazines, but it also encompasses photographs, ephemera and anything else you can imagine working its way into a composition.

Use what you've learned about colour and shape to inform how you approach working with these materials. Try recreating some of the earlier projects, but this time with found imagery.

We'll begin by exploring the wealth of textures offered up by printed matter, before examining how playful scale can build imagined worlds. There's also joy to be had collaging with architectural imagery, faces and features and even your own photographs.

Working with found materials makes it harder to follow exact step-by-step instructions, as you'll have different images to the ones I'm working with, but these projects will give you a starting point to get creative with your own unique materials. Let's get stuck in!

Magazines are brilliant for bringing texture into compositions. Fashion titles are brimming with images of fabrics and clothing with interesting folds and shadows, while images of nature will give you craggy, smooth, soft and rough surfaces to play with.

TEXTURE

As well as collaging with texture-heavy pages, you can take it up a notch and tear the paper instead of cutting it to create fluffy edges. Tearing the paper towards you will result in particularly soft white edges. Work in small sections to have some control over the line you make and experiment with how much of a white edge you're able to achieve. This technique is particularly good for creating the foamy tops of waves on a choppy sea or uneven hilltops in a landscape.

Beyond adding interest to figurative images, textures can also make for intriguing results when layered up to form abstracts. Try creating pieces that combine multiple textures from different sources, with a focus on colour and mood.

Seascape
In this simple seascape, multiple tones and textures are layered to form water. Snippets of fabrics sit alongside slithers of an image of crushed eyeshadow.

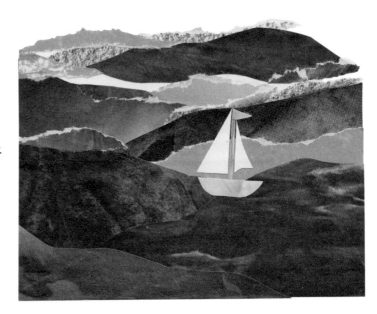

Galaxy

Shiny surfaces are great for
an out-of-this-world collage.

Top tip: Glossy and
matte magazines will
give you different end
results. Images cut from
gloss have richer, more
saturated colours and
an obvious shine, while
matte pages have a softer
quality to them.

Tomatoes

Red, crinkled paper
and a photo of bright
green leaves.

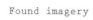

Found imagery

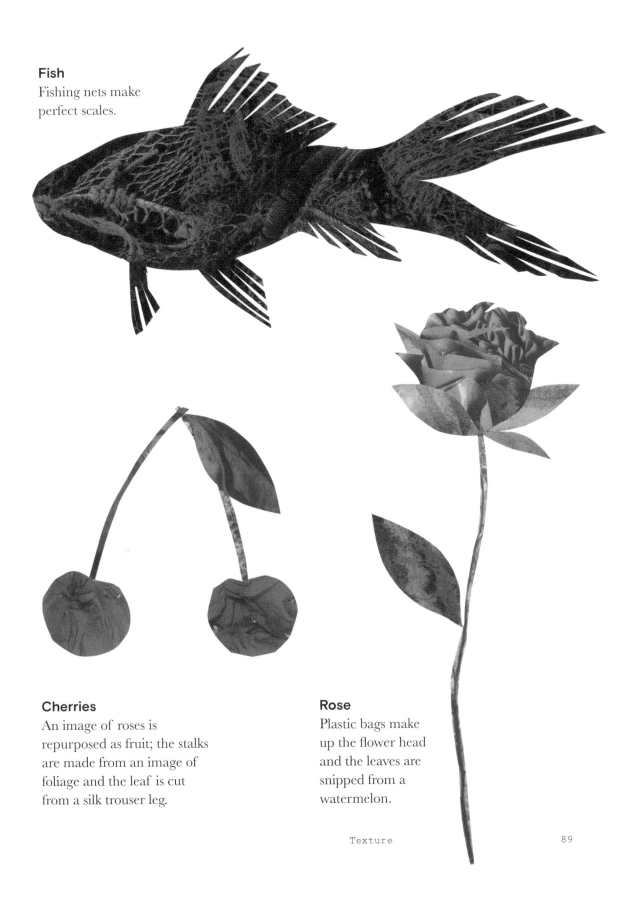

Fish
Fishing nets make
perfect scales.

Cherries
An image of roses is
repurposed as fruit; the stalks
are made from an image of
foliage and the leaf is cut
from a silk trouser leg.

Rose
Plastic bags make
up the flower head
and the leaves are
snipped from a
watermelon.

Flowers

Combine texture, pattern and colour to make a cluster of flowers and intertwined stems. Use whole images of blooms, plus ones you've made yourself by cutting out petal shapes, letting them overlap as they would in the wild. Although you'll want to use the rule of working from back to front in layers, you don't need to glue your largest elements first here. Let smaller flowers stick out from behind stems and let stalks cross in front of flower heads at different angles to avoid a predictable composition.

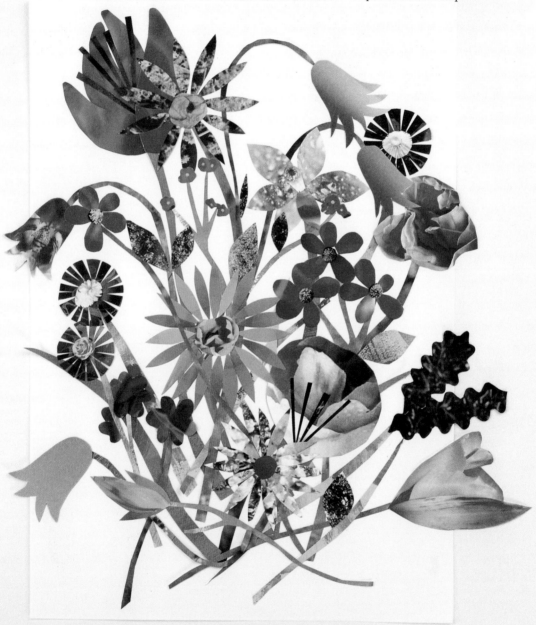

Found imagery

Top tip: While pattern is a decorative element that repeats, texture is something that can be felt. Imagine touching the images you cut out - how does the surface feel? Choose imagery you think would excite your fingertips.

Colour studies

Try generating lots of mini collages using just one colour at a time, searching out different shades and tonal values to work with.

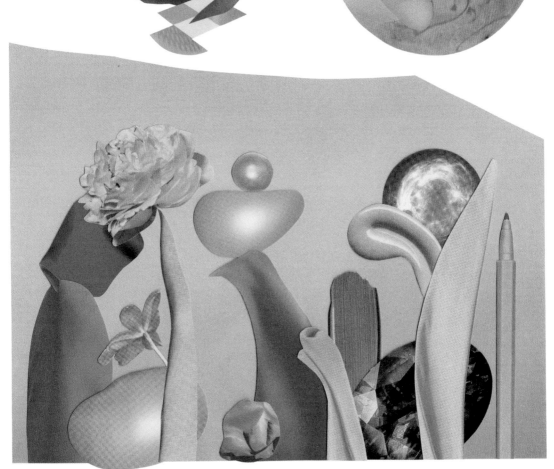

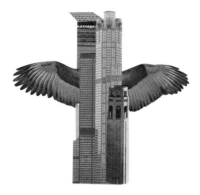

Much like the pages of a good book, collage has the ability to transport both the maker and viewer to new, imagined worlds. Simply by combining unexpected imagery together in the same frame, fresh lands and ideas begin to emerge. Bowls of cereal can be transformed into swimming pools with carefully cut-out figures diving into the liquid within, or wings can be merged with architectural elements to form creatures from other dimensions.

IMAGINED WORLDS

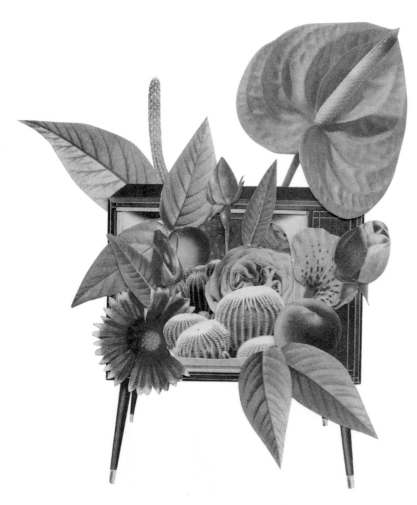

Across the next few projects, we will experiment with compositions that play with unexpected scale and interesting juxtapositions of imagery as a tool for creating nonsensical, surreal spaces. We'll begin with compositions that rely on just a few elements placed together to create new narratives and then move on to more complex compositions that propose fantastical landscapes or utopian cities.

I encourage you to embrace the weird and wonderful and throw the rules of reality out of the window. Allow your imagination to roam free and approach your blank page with a sense of child-like adventure.

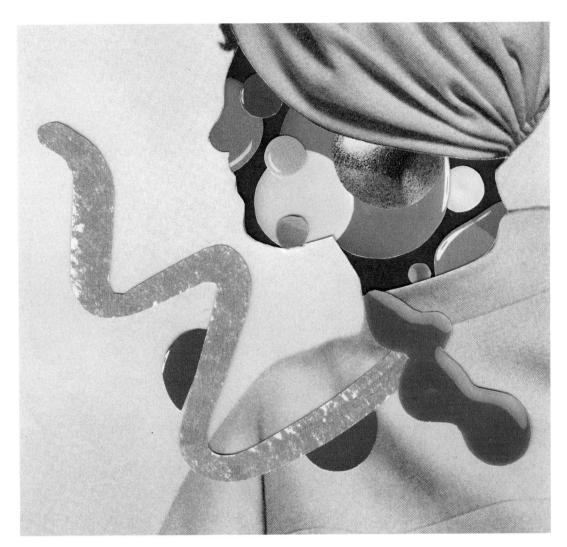

Using frames as portals to the unexpected

A fun way to start dreaming up imagined worlds is to replace the mundane with the magnificent. Pick images that would normally frame something quite ordinary – a picture frame, television set or window.

Use your craft knife to remove the contents and set about replacing it with something out of the ordinary. The edges of the frame no longer need to act as a boundary, so let the elements you add burst out beyond it.

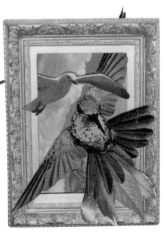

This type of collage plays with scale in interesting ways, repurposing small, everyday objects into sculptural forms that are human size. Imagine an alternate universe and the kind of things that might be surreal to see super-sized there. Although this piece is set against a plain background, it's easy to imagine what else might exist within the world it sits in.

PLAYING WITH SCALE

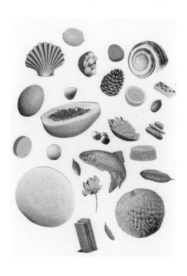

1. Begin by sourcing a selection of images in varying scales – seek out large images of small things and vice versa.

2. Place your largest images first. Imagine a line running across the middle of your sheet and position your elements along it – this will ground them on the surface and stop them looking as if they're floating in midair. Ensure any images with shadows are placed the right way up. Allow elements to overlap slightly and stack objects on top of each other to form intriguing structures.

Materials
A4 (letter) neutral-
 coloured substrate
Found imagery
Scissors or craft knife
 and cutting mat
Glue

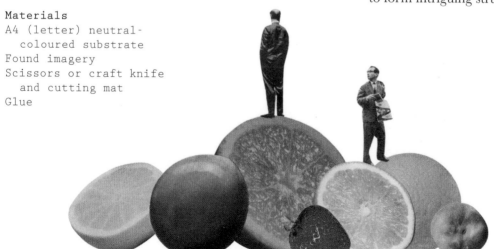

Found imagery

2

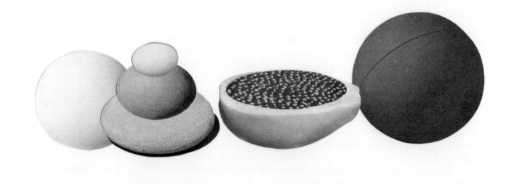

3

3. Add more to the foreground and height where needed. If you're including objects on a different plane (such as the feather here), adjust them until they look correct to the eye.

4

4. Continue adding and adjusting, making sure you're happy with the balance. You want the pieces to work harmoniously together and not be fighting for the eye's attention.

5 (overleaf). Make additions to any areas that feel sparse, without letting it become overly busy. The uncomplicated, bold nature of the composition is what makes it successful.

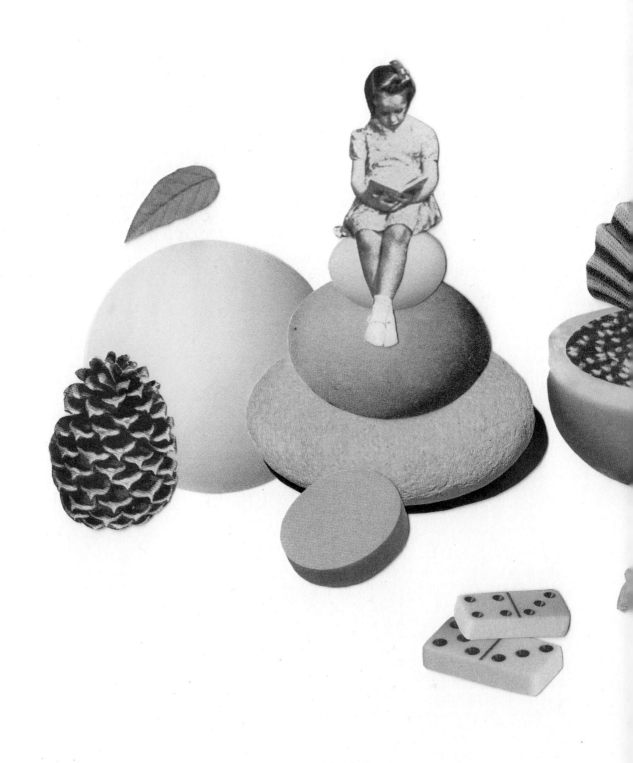

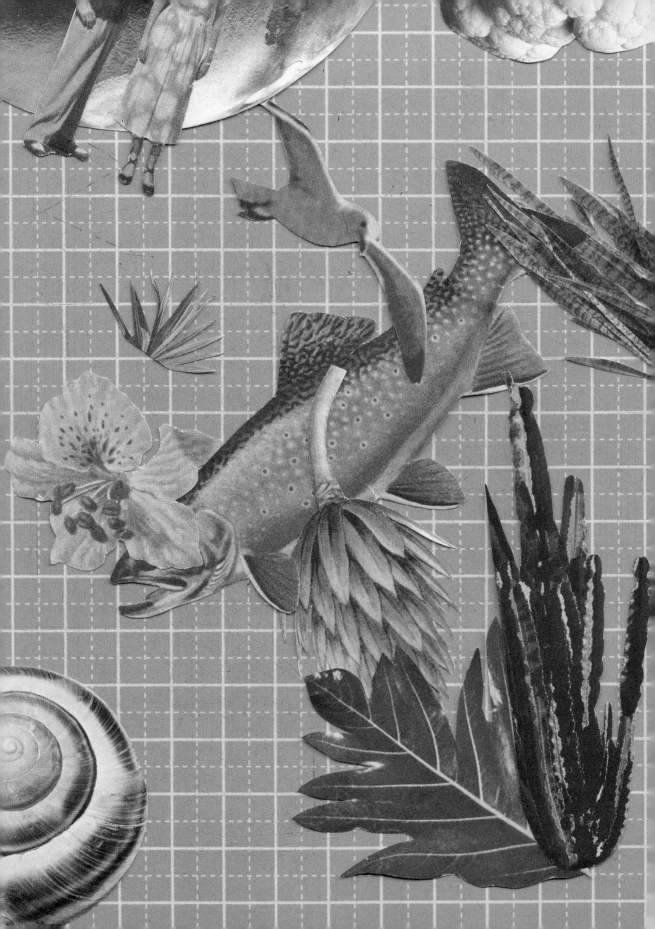

More playing with scale

Place your scale experiments on a range of backgrounds to form different narratives.

Why not try?

A shell and cauliflower repurposed to form a soaring rock face, with the addition of small cats reinforcing the shift in scale.

Let's have a go at building a full-page image. The aim is to create a seamless scene using imagery from multiple sources. At first glance, it looks like one coherent picture, but a second look will show a collection of elements not normally found in the same space.

A SURREAL PLACE

Materials
A4 (letter) neutral-
 coloured substrate
Found imagery
Craft knife and cutting
 mat
Glue

The embedding technique is useful in this type of work. Use your knife to cut a line in an image for another to be slotted into. Here a small section of the mountain outline has been cut so that the moon can be nestled behind it, keeping the line of the mountains intact.

1. Think about the kind of scene you want to create. I knew I wanted to pair this main image with additional mountain ranges, but also man-made structures, so I sourced imagery that was thematically different but tonally similar.

2. Find a good-sized image for the background. Place your layers on top, playing with the positioning until you're happy, ensuring messy edges are hidden. At this stage, position your images without glue so you can move things around if needed.

3. Now your skyline of buildings can be slotted in between the background and foreground images. Place them at different heights and combine different styles of architecture. Smaller buildings can be nestled within the layers.

4. I wanted my world to exist in an unidentifiable time and space, so I combined daytime imagery with a giant moon and rainbow. These additions draw the eye to the top half of the composition.

5. Finish with smaller details. I opted for a sailboat to add interest to the lower part of the collage and a tiny car parked up on the mountain edge. Once you're happy with your composition, stick each layer down.

Found imagery

1

2

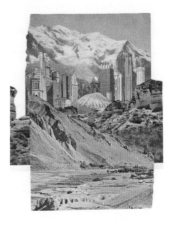

3

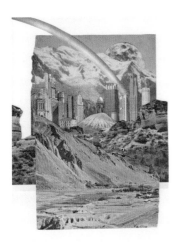

4

5

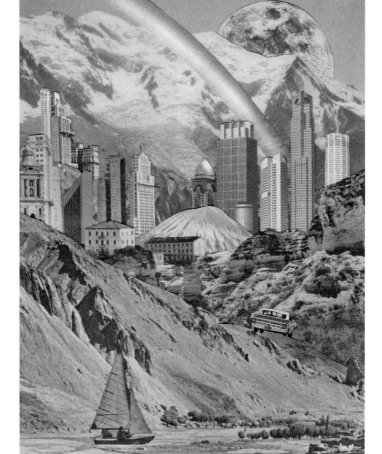

Materials
A4 (letter) neutral
 substrate
Jewels and insect
 imagery
Scissors or craft knife
 and cutting mat
Glue

Inspiration for this project was sparked when I flicked through a magazine and found an article about jewel beetles and their colourful, iridescent bodies. I thought it would be interesting to create a collection of imagined minibeasts made from jewels and diamonds, paired with insect imagery.

JEWEL INSECTS

 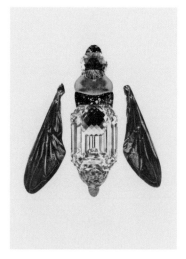

Look for shapes similar to the different segments on an insect's body.

1. Piece together a body from a range of jewels and textures. Let them overlap to roughly resemble an insect's main body parts and glue them down.

2. Next add a glitzy head and wings. Here they are all in proportion, but yours could have gigantic wings or multiple sets of them.

Found imagery

3. Now get to work with the sparkly embellishments. Use smaller gemstones and teardrop shapes, placing them symmetrically over your insect. Finish with eyes and jewelled antennae.

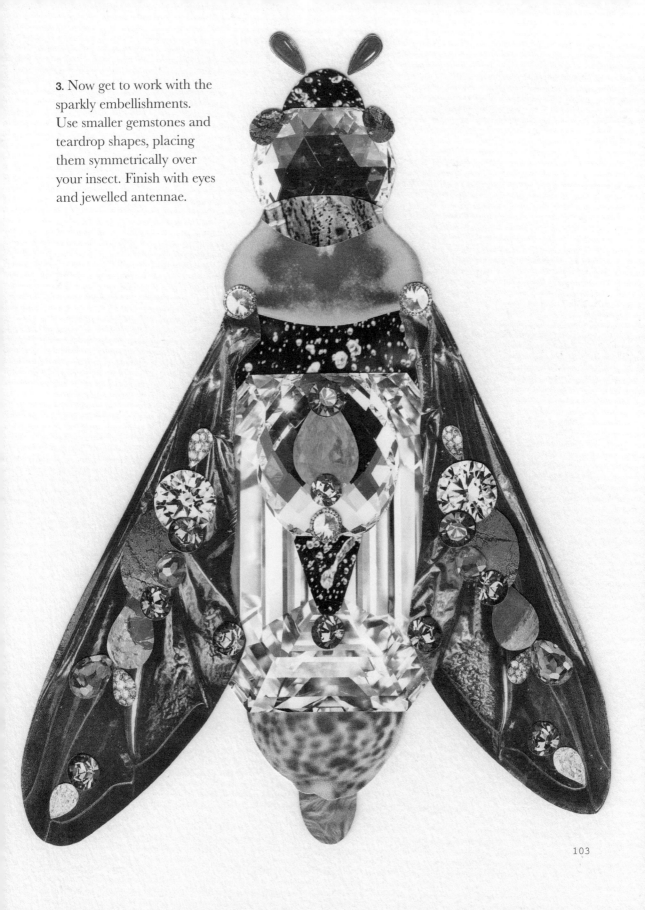

More ideas

Use white letter transfers on black paper to create labels for your insects like those you'd find in a natural-history display.

Top tip: Pictorial encyclopaedias are brimming with insect imagery. Photocopy pages to work with and use the anatomical drawings to guide the shapes you make.

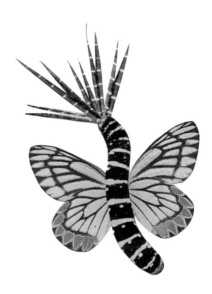

Create otherworldly habitats for your creatures to scuttle about in. Cut a range of leafy imagery and roughly mosaic the pieces together to form a background.

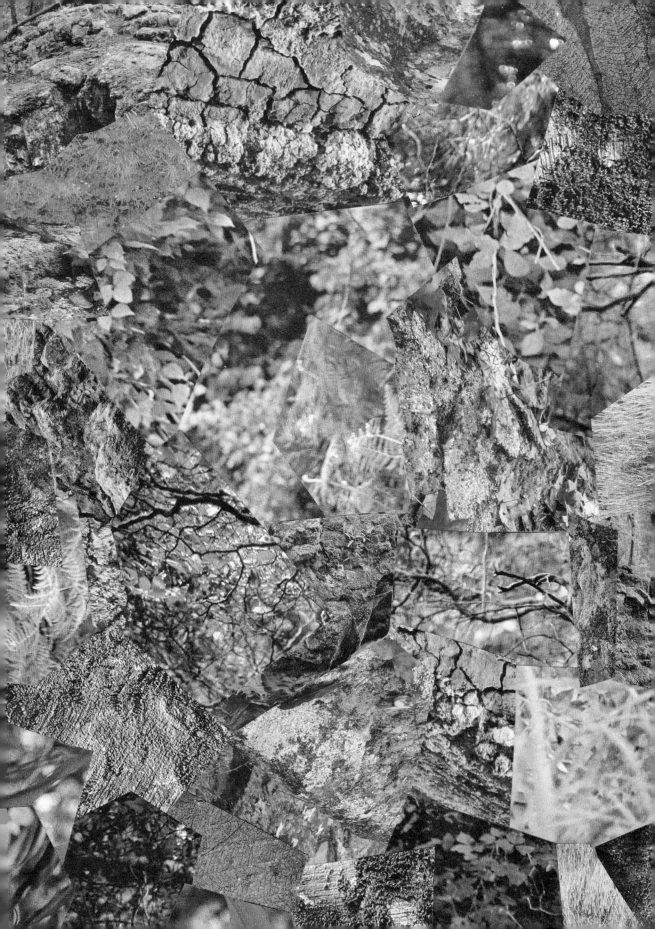

Collage can be used as a tool for conveying an atmosphere, space or idea. It's a brilliant process for enabling us to get thoughts down quickly and for explaining creative concepts. Architects and interior designers often employ it to give clients a feel for the finished result without having to rely on clinical renders to do the job.

MOOD BOARDING

WORK LIKE BILBAO

Mexican architect Tatiana Bilbao (b. 1972) uses collage instead of three-dimensional renders to give her clients a feel for future buildings. Instead of a rigid idea for a final outcome, collage allows her studio to present something that involves process and is open to interpretation and change.

Think about it like a mood boarding exercise, concerning yourself with atmosphere over composition. Pair found imagery with painted papers and hand-cut shapes. Translucent paper is great for unifying multiple images or for knocking back high-contrast areas.

I've always thought it would be fun to be a playground designer – what better way to facilitate fun! For this collage, I had a go at inventing my own, drawing on a fascination with Japanese playground design, and the public playscapes designed by sculptor Isamu Noguchi (1904–88).

I wanted my vision to comprise bright colours and dynamic structures, and for the page to feel full of life. I chose not to stick my elements down and only used Blu Tack (reusable adhesive), letting the edges stay loose to reflect the instinctive feel it had when I started piecing it together. When picking imagery, I gravitated towards objects and structures that looked as if they could be clambered on, repurposing architectural elements and everyday objects into things that could be scrambled over or hopped across.

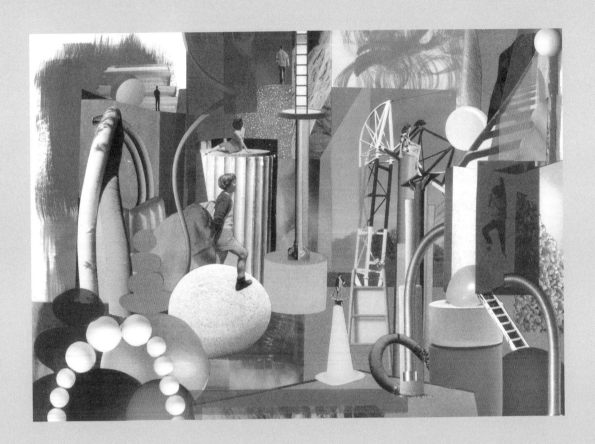

More project ideas

As well as creating imagined spaces, this technique can be used to conceptualize projects in day-to-day life. Mood boarding is used in fashion, with designers collating different textures, swatches, photographs and cuttings to form the basis of their next collection. Use collage mood boarding as a technique to visualize ideas for your own capsule collection, to cement the mood you want for an event or as a starting point for an interior project at home.

Cities lend themselves well as a subject, as they're living, breathing collages in their own right. Walk down a city street and you'll find a hodgepodge of architectural styles, with old and new juxtaposed in the same frame. The buildings, cranes, signage, scaffolding, billboards, trees, people and cars all exist as layers in a cut-and-paste composition.

BUILDINGS AND CITIES

If you're anything like me, you'll soon start dissecting every view into its individual layers – the pavement with its patchwork of concrete-block styles, Tarmac pasted over the top and spray-painted directions left by workmen, finished with a sprinkling of leaves and some splodges of chewing gum.

The projects here employ techniques that celebrate the mishmash feel cities often have, throwing all manner of architectural styles into the same piece, before using a mosaic approach to reconstruct familiar sights using your own snaps.

Found imagery

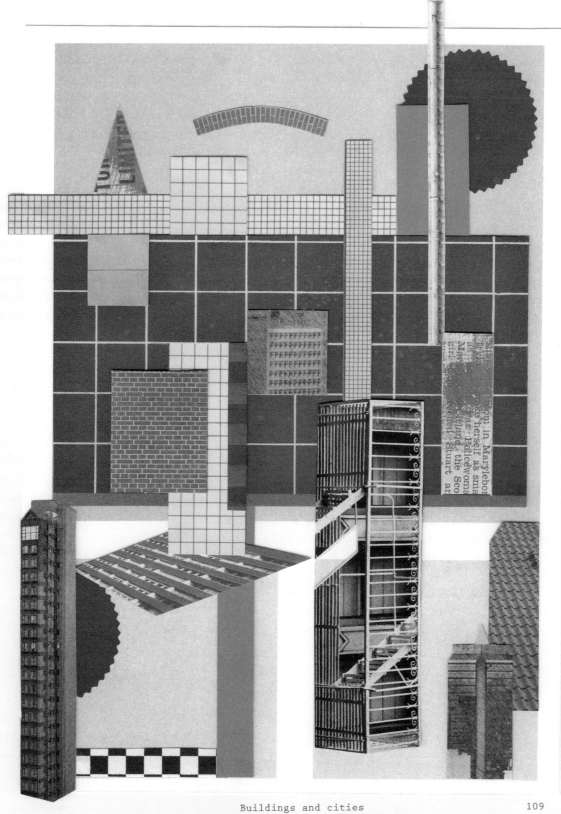

Building blocks

Let's start with a series of individual buildings and construct them using a mix of architectural styles. Cut out chunks of different buildings, thinking of them as blocks that can be joined together, with your glue as the cement. Lift imagery from homes, office blocks, churches or villas, as well as by cutting building-shaped blocks made from just pattern or texture.

Once you've got lots of building fragments to work with, you can begin constructing. Choose unexpected combinations and layer them up alongside each other to form hybrid structures.

Ask yourself: What space and time do your buildings belong to? Are they located in a city of the future or one from the past? Are they industrial, residential or places to have fun in?

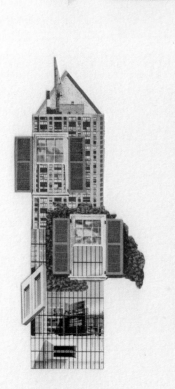

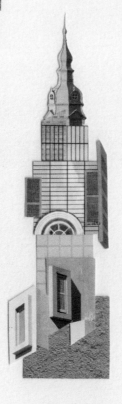

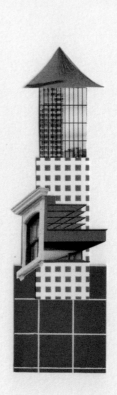

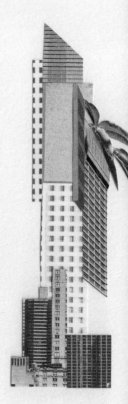

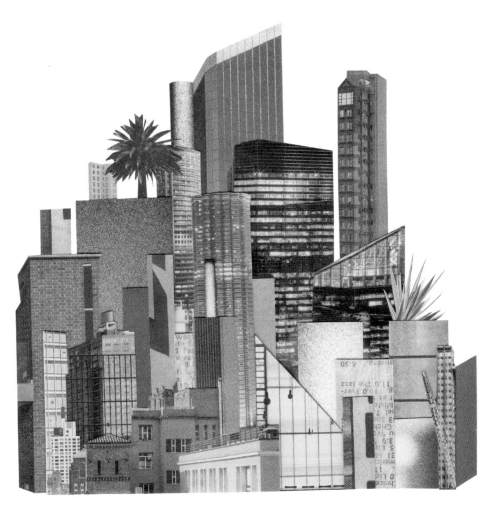

More ideas

Once you've designed buildings using traditional materials, try a more unusual approach. Can you transform an image of a drink can into pub frontage or a photo of a sculpture into an avant-garde museum building?

Imagine slicing the front off a building to expose the floors within. Collage the different floors, furniture and staircases you'd see.

Top tip: The gridded layout of newspapers makes them perfect for creating buildings. The variation in how tightly packed the words are will give you different tonal values to work with, which is useful for depicting areas of light and shade.

I adore where I live and work and often find myself photographing buildings, trees and sunny skies when I'm walking to and from my studio. For this piece, I wanted to capture my London area — and what better way than through my own lens and with my own photos?

MOSAICKED CITIES

Materials
A3 (tabloid) card
 substrate
Photographs
Scissors or craft knife
 and cutting mat
Glue

A city is fun to construct, as it's bustling with so many styles, but this technique can be used whether you live in a metropolis, town or secluded village. Spend a couple of days snapping things that catch your eye, vaguely thinking about frames that fit into three categories: ground level, buildings and sky. Take photographs at different times of the day, in varied weather and from a range of angles. Shooting from a range of perspectives will give you a warped and energetic finished result. I printed my photos at a variety of scales and made repeats of my favourites.

This technique isn't far removed from the feel of David Hockney's 'Joiners', made in the 1980s, where he pieced multiple photographs of the same thing together to form one big image of the subject. Gridded at first using Polaroid snaps, he later switched to lab-processed photographs for a choppier impression.

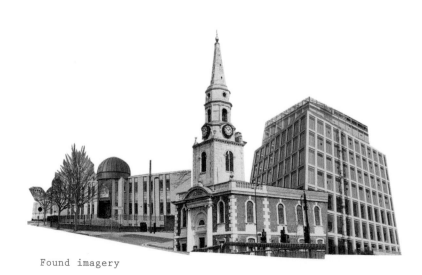

Found imagery

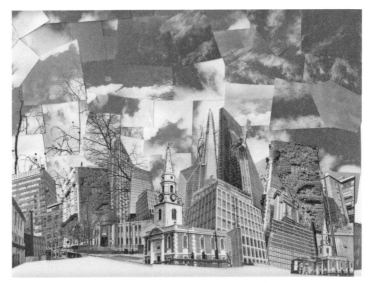

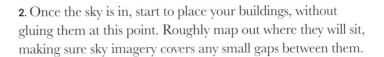

1. Begin by piecing together a patchwork sky. You want it to look fragmented but still flow, so clouds can be grouped together and pieces with the same tonal value can sit side by side. The sky should take up roughly one-third of the page.

2. Once the sky is in, start to place your buildings, without gluing them at this point. Roughly map out where they will sit, making sure sky imagery covers any small gaps between them.

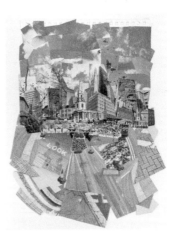

3. Now you know how much space the buildings will take up, you can block out the foreground using photos of road and pavement. Position the images as if they're sprawling downwards from a central line where the buildings sit. Either remove the buildings at this point or keep them in place but not glued down, so that the pavement section can be slipped in underneath.

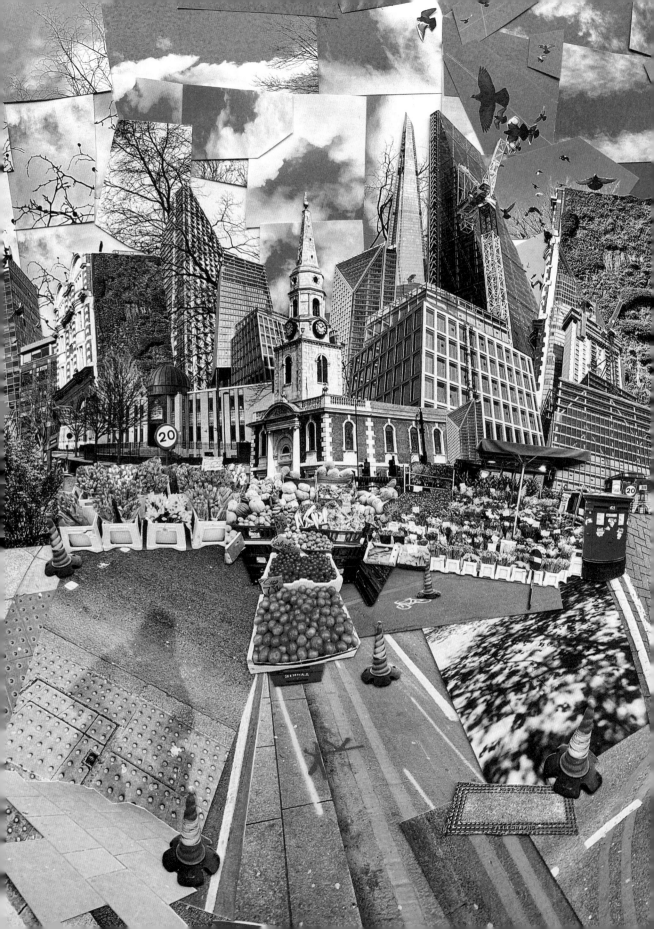

4. With the bottom and top sections in place, you can glue the third and final architectural layer and add colourful elements such as market stalls, flower stands and postboxes to the foreground.

Hastings

The collage below is inspired by one of my favourite views in Hastings, the town where I grew up. Instead of using my own photographs, I gathered imagery from magazines to patchwork together the scene.

A CELEBRATION OF PLACE
Take a look at *The Block*, 1971, by Romare Bearden (1911–88). Consisting of six panels, each section is a celebration of Harlem in New York City and represents different aspects of life in the neighbourhood. It was a place that meant a great deal to Bearden and his tribute is bursting with colour, movement and the community he knew going about day-to-day life.

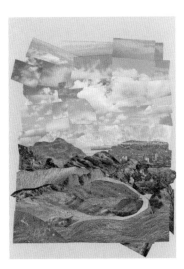

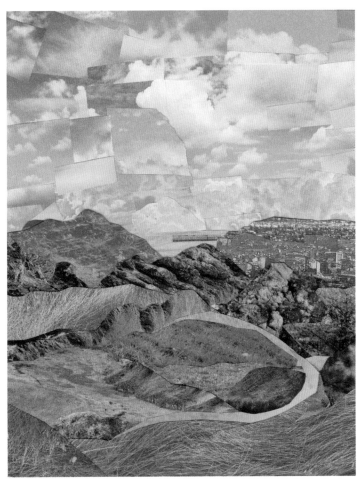

I'm always on the lookout for billboards that double up as accidental collages. Layers and layers of previously pasted posters that have been ripped off but not fully removed are heavenly! Not only do they make great compositions in their own right, they also make great base images to be worked onto. Keep an eye out for them and print photos of your favourites to incorporate into abstract works.

RIP IT UP AND START AGAIN

Additional photos positioned with washi tape and offcuts from my mosaic collage have been combined here to mimic this ripped-up aesthetic.

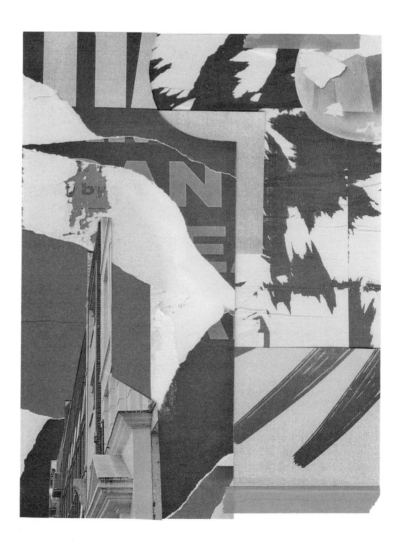

Found imagery

An extra idea

Developed by the artist Max Ernst (1891–1976), frottage is the technique of taking a rubbing of a textured surface. Use it to create a selection of interesting papers to work with, gathered from the area you live in. Tiles, patterned paving slabs and manhole covers all work well for taking rubbings with crayons and you can then turn your patterns into abstract representations of your surroundings.

WORK LIKE ROTELLA

Mimmo Rotella (1918–2006) was a key figure in the décollage movement, a technique which involves removing areas or tearing pieces of an existing image rather than building a collage up in the traditional method. The Italian artist was inspired by the ripped film posters he saw pasted across Rome and began tearing them down at night, working the sections he'd salvaged into compositions back at his studio.

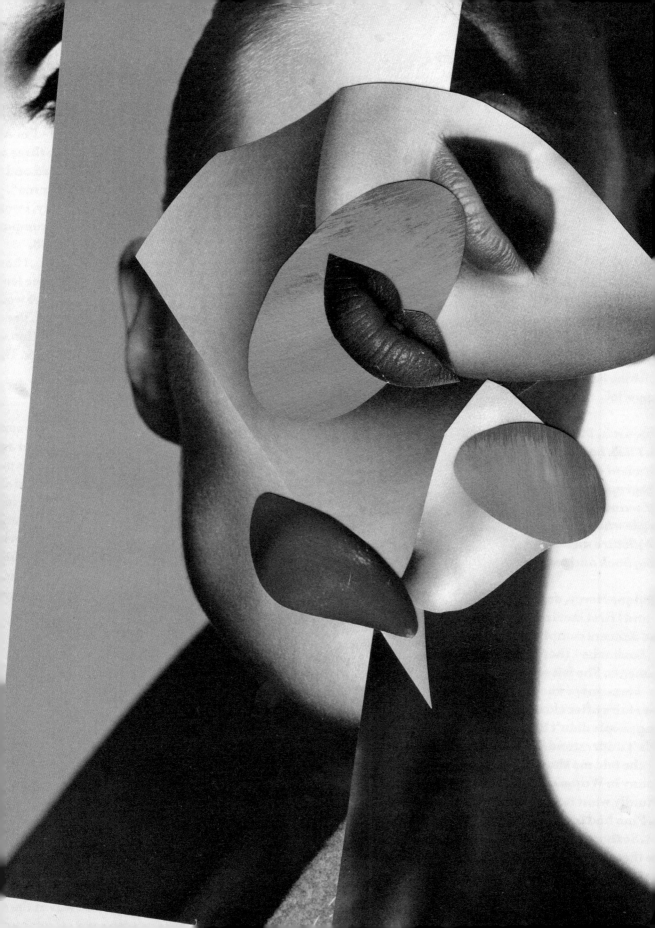

Materials
A4 (letter) paper or
 card substrate
A selection of whole
 faces and individual
 features
Painted paper scraps in
 different colours
Scissors or craft knife
 and cutting mat
Glue

Perhaps the most relatable subject matter of all, collaging with faces, features and bodies opens up space for multiple themes to be explored. Mood, self-expression and identity can all be a focus, as well as connections with fashion and style. While magazines are an obvious place to look for imagery to manipulate, you can also use your own photographs for self-portraits, putting a personal spin on the subject.

FACES AND FEATURES

Top tip: Scan or photograph your image to help identify if an eye or nose needs shifting. It helps to flatten the work and for your eye to see the collage as a whole.

Build a face

My initial plan was to create a tone and shadow-focused face, but having spent a while fighting with the elements on my desk and getting nowhere, the introduction of an eyeshadow-clad eye and leftover painted paper scraps sent my work in a new direction. Sometimes, it's good to switch things up if you're feeling stuck.

Start by flipping through magazines and pulling out potential faces or features to work with. It could be a single nose or a whole face. At this stage, you're not necessarily thinking about

if and how they work together, simply whether or not you're drawn to them and if they're roughly the same scale.

There's a fine balance between making an interesting face with fragmentation and distortion, and producing something alien or clown-like. Picking imagery of a similar size can help steer it away from the comedic. Have a healthy pile of imagery to work with and more magazines to flick through while working. Glue layer by layer when you're happy with the positioning.

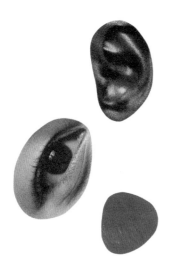

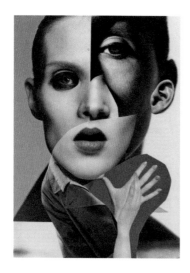 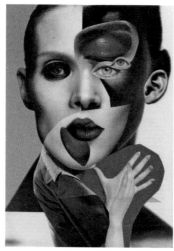 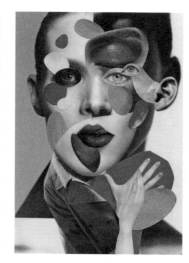

1. Begin by getting the base of your face down. Align jaw lines from multiple images to form a strong outline and framework for other elements to sit within. Your base could comprise two or more images jigsawed together. Add features that work as connectors between images, such as the nose here.

2. Bring in additional features as well as replacing existing ones. Add pops of colour if you're working with black-and-white imagery.

3. Continue placing colourful, smooth-edged shapes and more features, slipping them both behind and in front of existing layers until you're happy that the balance works.

Mix and match faces

Cut out lots of faces, then crop them into smaller parts. Join them back together, fusing pieces from different faces. Approach this experiment as the Cubists did, combining multiple views and perspectives together in the same image.

Project idea: Instead of using magazines, use your own photographs to make a self-portrait.

Found imagery

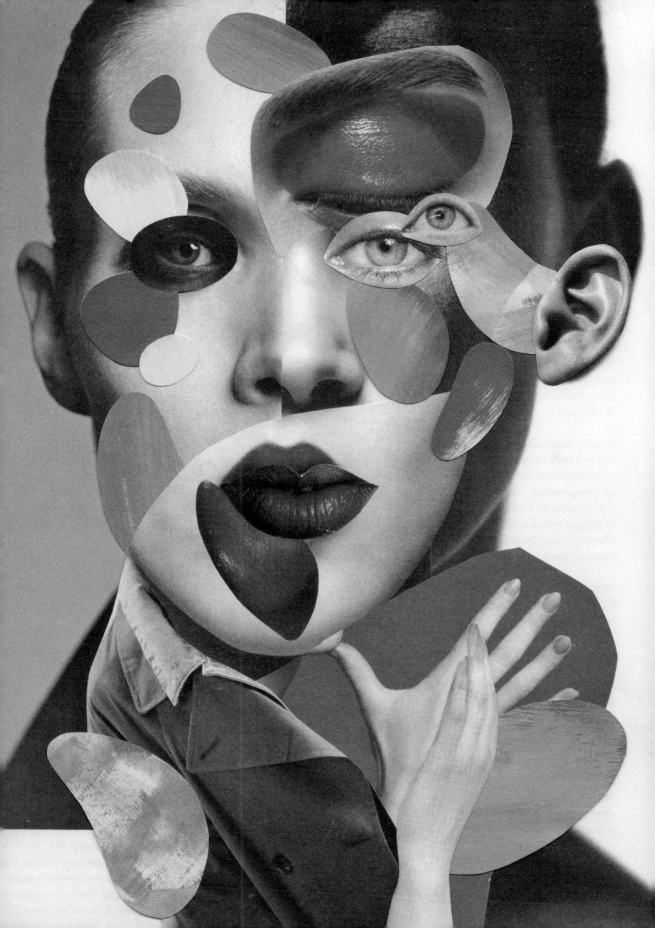

Sometimes, simplicity is key. The majority of these silhouettes are made from just two images. When searching for figures, choose ones that are uncomplicated and have defined edges. Choose images that have simple backgrounds that won't be in competition with whatever image you layer behind it.

SILHOUETTES

 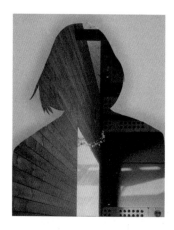 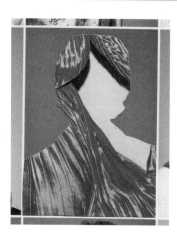

Use a craft knife to cut your silhouette out. Slip a piece of white paper behind it once you've taken away the image to make sure your edges are clean and crisp, removing any little bits of the image missed on the first cut.

Now you can find the perfect picture to pair with your silhouette. Use your cut-out as a viewfinder, moving it across images to find the best positioning. Try lots of combinations until you find the winning coupling.

When moving this silhouette over an image of a woman in a pink dress (top right), I realized I could make the fabric resemble a fringe, with the shadows adding to the hair-like shape created.

Opposite, I kept the wisps of hair in the bottom left collage in place instead of making them part of the silhouette, and found an image of coral and anemones that complemented it perfectly.

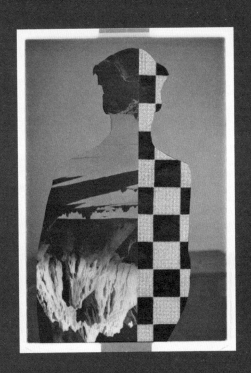
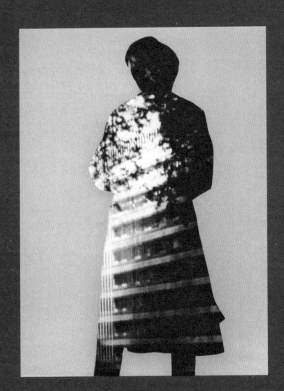

This is a completely different approach to creating faces, using ephemera found on your doormat to construct features. It's inspired by the collages of Ivan Chermayeff (1932–2017), an American graphic designer who created logos for some of the biggest brands around, and in his spare time made collages that often took the form of imagined characters.

IVAN CHERMAYEFF-INSPIRED FACES

Chermayeff used readily available materials, including envelopes addressed to him (his secretary became good at opening post so they weren't damaged), paper and packaging picked up off the street, airline tickets and drawings made by his son Sam when he was young.

What's great about Chermayeff's work is its simplicity – a mail mark hinting at an eyebrow or a vertical label implying a nose is enough for the viewer to form the rest of the face in their mind. There's great skill in being able to convey so much with so little.

Build up your own stash of materials to work with, saving envelopes with handwritten addresses and patterned interiors, exhibitions and travel tickets, and fun stickers. Create a whole cast of characters with different facial expressions!

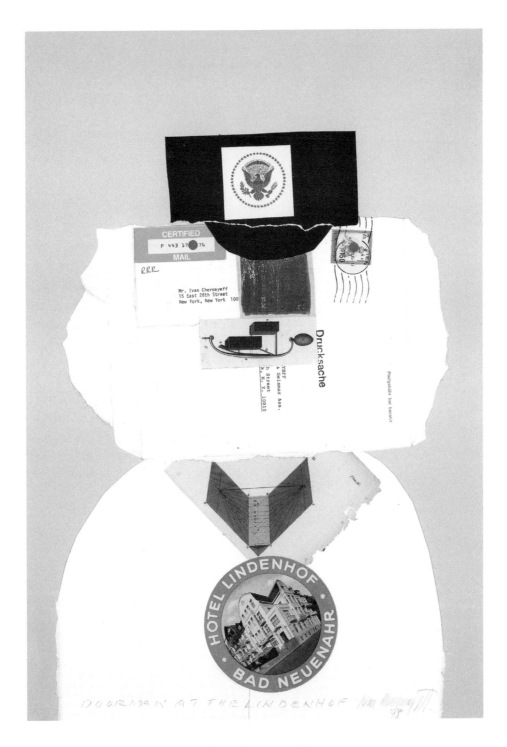

Ivan Chermayeff
Doorman at the Lindenhof, 1998

Ivan Chermayeff-inspired faces

1. Find a good-sized envelope to use as your base. Keep the sealable edge up to suggest a hair style.

2. Start adding features. The blue stamp on this envelope works well as an eye, with the wiggle of the postal mark hinting at eyelashes. The direction of the handwritten name provides structure for where a nose could be.

3. Keep any pull tabs you remove from cardboard envelopes and use them to exaggerate the shapes of a nose and eyebrow with an upside down 'L'. The texture of the ripped edge is very satisfying. Amplify the eyes a little by adding bold, black stickers (or pieces of black-painted paper). They don't need to match or be symmetrical if you want to make a jaunty face.

4. Finish your creation with a mouth and ear. I've used a giant yellow 'O' from a pack of alphabet stickers and an arrow from the back of an envelope. Glue when happy.

Another example:
A surprised face framed within the window of an envelope, topped with a stamp hat.

Found imagery

1ST CLASS
MAIL

Royal Mail
Mount Pleasant
Mail Centre
11-01-2022
24316713

Royal Mail
supporting youth
mental health with
ACTION FOR CHILDREN

At times, it's fun to do away with most of the face and use just one feature. I collected a vast selection of lips over a couple of months, squirrelling them away until I had plenty to use for a repeat motif. My initial idea was to position them all across the page, but on completion, that composition wasn't very exciting; the lilac base felt saccharine paired with the pink lips, and the placement too obvious.

REPEATED MOTIFS

I played with a different, looser composition on a background that worked better tonally, before switching it up completely and introducing a landscape. The lips turned on their side create a surreal, fence-like structure stretching across the mountainside, which is far more unexpected and one hundred percent more fun.

Build up your own collection of features until you have a good selection to work with. Can you turn them into something unpredictable?

Found imagery

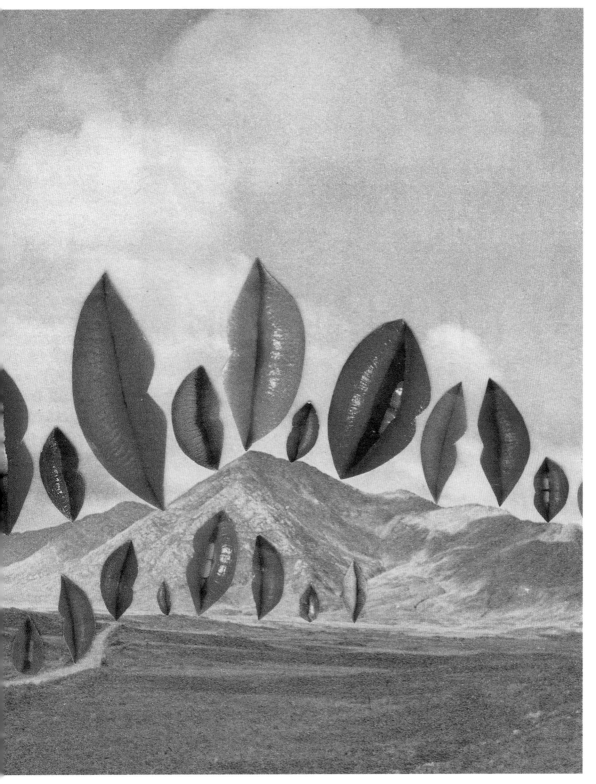

Materials
A4 (letter) neutral
 substrate
Paint and paintbrush
Coloured washi tape or
 masking tape
Imagery of fabrics,
 clothing and body parts
Scissors or craft knife
 and cutting mat
Glue
Stickers

Approach this step-by-step as if you're forming a fashion feature in a magazine. Choose clothing you're drawn to to devise your own capsule collection and piece together interesting poses from multiple bodies. Magazine layouts are a great source of inspiration for this kind of work, as they often employ collage as a graphic technique.

MULTIPLE BODIES

1. Begin by painting your base with a colour of your choice. Allow the brush strokes to remain visible and parts of the base colour to show through, including the edges. This will provide instant texture to work on top of.

2. Roughly tear your washi or masking tape into abstract shapes and layer them up across your page.

3. Piece together your first figure. Look for arms adopting interesting poses and clothing that pops against your base colour. Loosely form the shape of a body, but don't feel the need to represent every part. The viewer's eye can fill in the missing areas.

4. Continue to add figures either side of your first, allowing bits to overlap and cross in front. Be inventive with your use of scale and allow an extra leg or arm to appear if it works.

Artist inspiration
 Quentin Jones
 Jazz Grant
 Lunga Ntila
 Ernesto Artillo
 Johanna Goodman
 Linder Sterling
 Mickalene Thomas
 Wangechi Mutu

Found imagery

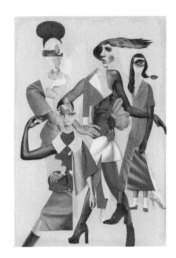

5. As shown above, once your three main bodies are in place, a figure can be added in the foreground. Choose dynamic limbs and bright colours that complement your other figures.

6. Make adjustments to any parts that don't feel balanced, then reach for your stickers, placing them wherever a pop of colour is needed.

7. Finish your piece with small details and shapes that match the colour palette you've been working with.

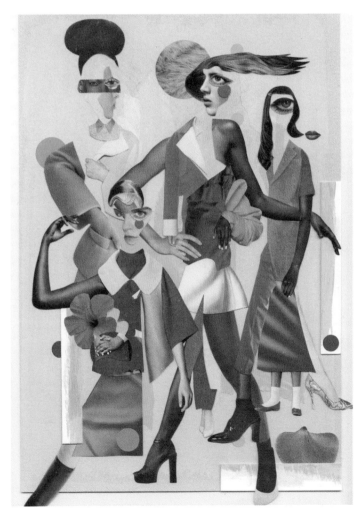

BEYOND THE FLAT PAGE

The techniques you've experimented with already throughout this book can also be applied to projects that extend beyond the flat page. Why not try adding depth by working with mixed media or adding an extra dimension with a straightforward folding technique? Alternatively, an assortment of objects can be used to form three-dimensional assemblages.

 This section also takes a look at collaborative collaging and what can be achieved when multiple voices come together to create.

At first glance, this project looks complex, but it only takes a simple folding technique to form a base to build upon. I favour a maximalist approach when it comes to interior design, so my pop-up room is packed with colourful furniture and accessories, but you might opt for a minimal aesthetic.

POP-UP ROOM STEP BY STEP

Materials
A4 (letter) card substrate in a colour of your choice
Bone folder or ruler
Additional card for backing flimsy elements
Furniture and home-accessory imagery
Scissors or craft knife and cutting mat
Glue
Blu Tack (reusable adhesive)

The room's gallery wall is created using collages from the pages of this book, printed out as miniature artworks. Alternatively, you could find pictures in magazines, print out famous collages or use your own photos for a personal touch.

3. This box shape will prop up your feature piece of furniture, so you'll want something higher and wider to cover it. I've gone for a long sofa with lots of cushions added to it.

1. Start by taking your card and folding it in half. Make two even vertical cuts up from the folded edge about 3–4cm (1¼ / 1½ in) length and about 10cm (4in) apart.

2. Open the paper back up and pull the rectangular shape you've made through, pressing it down to form a box shape. Use a bone folder or ruler to make a crisp fold.

Beyond the flat page

5. Once you've sorted the key features, have some fun dressing your room. On the back wall, build up a gallery of mini artworks. Use a variety of sizes and give them colourful frames that will pop against your background.

4. Back the sofa with card to make it sturdy, and place it with Blu Tack to check it works. Remove it so you can work on the rest of the room, bringing it back in now and again to check everything looks good. A fireplace positioned above the box provides a nice edge for accessories to be added a little later.

6. Create tiny shelves cut from card in a contrasting colour. Add a tiny bracket on each side that can be glued to your wall.

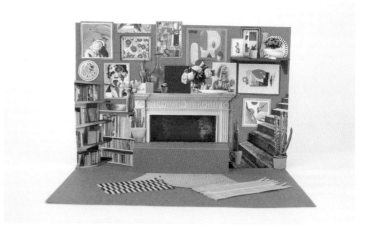

7. Design some rugs for the floor using patterns cut from magazines, or make your own from painted paper and wax pastels. Cut the edges to suggest frayed fabric.

8. Stairs suggest your room extends to an entire house – you could also include a door or window. Slightly angled bookshelves prevent the scene from looking flat.

9. Once your larger elements are in place, add the finishing touches that will bring your room to life. Bring in plants, vases of flowers, ceramics and art objects. Glue your sofa in place when you're happy with your placement.

To add depth, you can create L-shaped tabs for some of your objects, such as those sat on the shelf. Back them with card so they don't flop over, then glue them in place.

To pull the whole piece together, add some floor furniture. Add a comfy chair backed with card and an L-shaped tab made in the same colour as the floor so that it blends in.

10. Make a coffee table by cutting two circles (with roughly a 7cm (2½ in) diameter) of contrasting coloured card, one circle slightly smaller than the other and with a scalloped edge, and stick them together.

11. Cut a length of card in the same colour as the larger circle and make small cuts along one of the long edges to

create tabs. Fully remove one tab at the end, then glue the two ends together to form a loop. Dab each tab with glue and attach it to the underside of your circles to form a table.

Top tip: If you find your base is unable to support the weight of your finished collage, back it with another piece of card. This will also hide the exposed cut-out shape at the back.

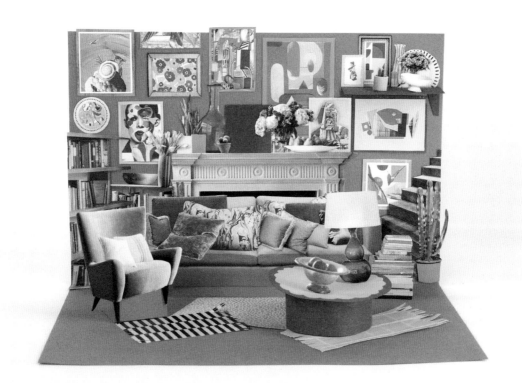

Other ideas: This pop-up approach can also be used to create cityscapes, comic space maquettes and mountain scenes. Think of them as set designs, where miniature figures could dwell.

Alternatively, you could concoct totally abstract compositions like this example, which is built onto a circular base.

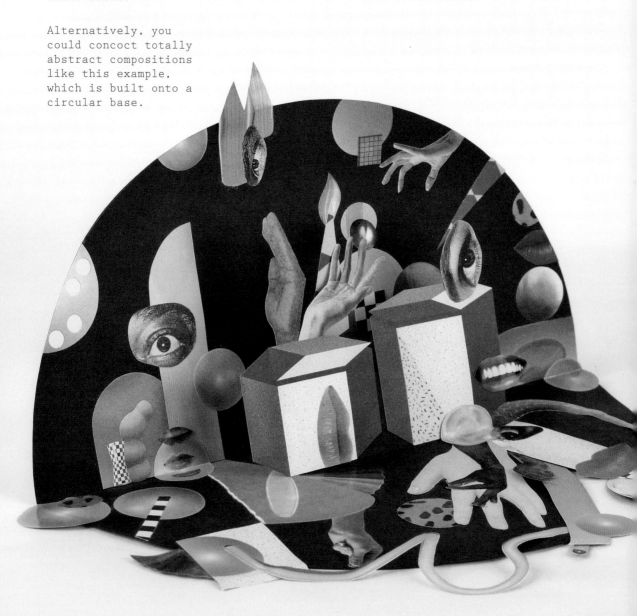

Beyond the flat page

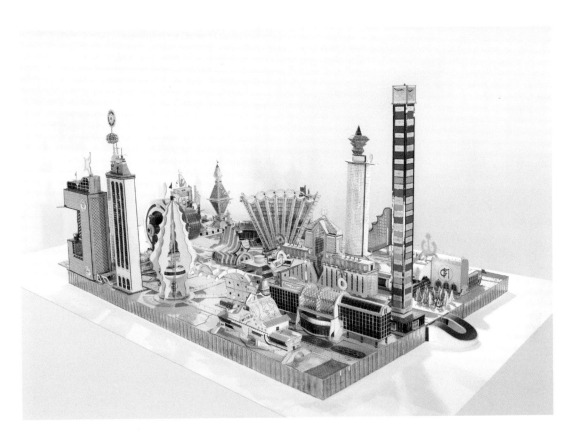

Bodys Isek Kingelez
Kimbembele Ihunga, 1994

ARTIST SPOTLIGHT
Bodys Isek Kingelez (1948–2015) is one of my favourite artists. Born in what was then the Belgian Congo, he moved to Kinshasa, the capital of the newly formed Democratic Republic of the Congo, in the 1970s, where he first started making his incredible artworks. Influenced by a place rapidly redefining itself, Kingelez created utopian proposals for cities of the future. He transformed everyday materials such as paper, cardboard, plastic, fizzy drink cans and packaging into complex sculptures that reflected the dreams he had for his country. Alongside single sculptures, he also constructed sprawling networks of fantastical cities peppered with civic buildings, public monuments, pavilions and skyscrapers.

bits when throwing out papers) just general interest.

Mixed media refers to artworks that combine multiple materials. Although primarily still creating a two-dimensional outcome, using mixed media can add a subtle depth and enrich the surface of a collage in a way pure paper works don't allow for.

MIXED MEDIA

We've come full circle back to colour and shape being the primary focus, so refer to those early collages you made when approaching mixed media work (see page 38). Note in these examples how elements touch, connect and are layered. Translucent fruit wrappers and tissue papers are great for this. In your own work, try fusing paper, magazines, paint, ink, packaging, gold leaf and other flat materials together.

Collecting collage material on a trip

The materials pictured are just a few of the snippets I collected during a trip to New York. I kept hold of ticket stubs, stickers, food wrappers and other bits and pieces that caught my eye. Back home, I collaged what I'd collected to form a personal visual diary. The individual fragments remind me of specific places I visited and what a great time I had. Try it yourself next time you go on holiday or take a day trip somewhere new. Pack an envelope that you can stuff full with the paper treasures you find. You could also incorporate holiday snaps, printing them at different scales and using fragments to form abstract textures.

Kurt Schwitters
En Morn, 1947

Kurt Schwitters
Opened by Customs, 1937-8

Assemblage is essentially an extension of collage, but instead of using only paper, all kinds of materials get the green light. If you can think of it, you can use it.

ASSEMBLAGE

The vast array of materials available to work with can be overwhelming, so it might be easiest to think of a theme or common thread to build your assemblage around. It could be a colour palette, repeat shape, or objects tied to a specific place such as the beach. If you prefer a less-ordered aesthetic, you could argue that an eclectic group of objects has a connection, simply by being picked by you. There's no way of knowing the wonderful possibilities offered up by assemblage without giving it a go and letting the process lead the way.

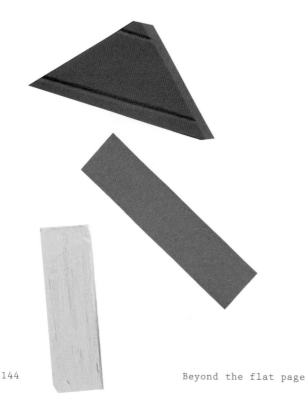

Beyond the flat page

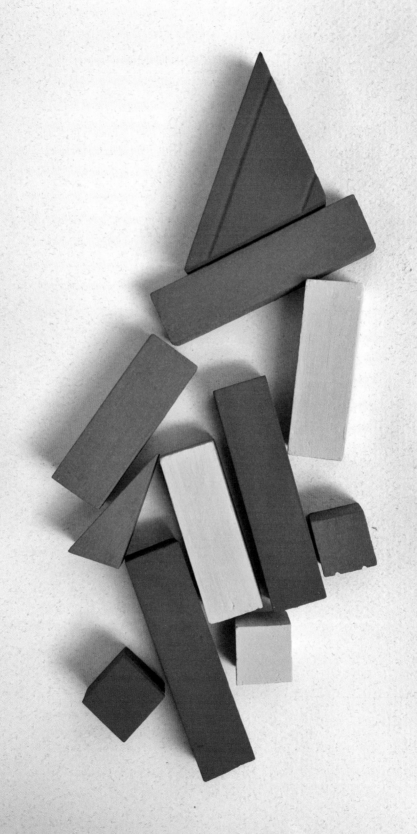

Here are just a few of the materials you might consider using:

Wood
Stones
Shells
Toys
Bottle caps
Packaging
Rope
String
Fabric
Coins
Matchboxes
Machine parts
Cork
Plastic

As well as the individual objects and ephemera that will form your assemblage, give thought to the structure that might house it. Simple box frames can be sourced online and will give you the depth needed to configure 3D objects in a museum-esque way. Displaying a collection behind glass can instantly elevate everyday objects into special treasures.

Rummage through vintage homeware, boot fairs and online listings for items that will do the same job – old letterpress printer trays, cabinets or interesting pieces of wood you can attach or build your assemblages onto.

Additional artists to look at:

Eileen Agar
Joseph Cornell
Betye Saar
Robert Rauschenberg

ARTIST SPOTLIGHT
Take a look at the work of legendary British pop artist Peter Blake (b. 1932). Alongside painting and collage, collecting and assemblage is an integral part of his practice, with other artists associated with the medium such as Kurt Schwitters (see page 143) and Joseph Cornell (1903–72) being hugely influential on his work. *Museum of the Colour White 2* is a satisfying study in white objects, while other assemblages consist of found items from family holidays, mementos and souvenirs, collected, ordered and curated by Blake over the years.

Top tip: You'll need a stronger type of glue to stick your objects with when making assemblages.

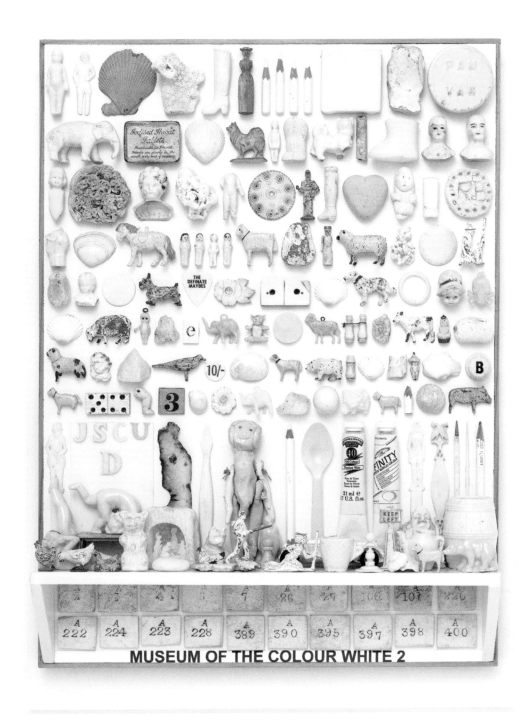

Peter Blake
Museum of the Colour White 2, 2002

There's something about the repetition of pulling paper over and under while weaving that's so soothing. You can use paper weaving to create standalone pieces or use the technique within classic collaging to lift your pages.

WEAVING

Materials
Two different pieces of
 coloured paper of the
 same size
Pencil
Ruler
Craft knife
Cutting mat
Glue

Outlined below is the most straightforward way to weave with paper, using just two colours. Once you've grasped the basic technique, you can become more experimental. You'll find plenty of templates online to follow for intricate patterns and designs.

1. Use your pencil and ruler to mark out where you're going to make your vertical cuts on one sheet of paper. Mark 1cm (⅜in) down and 1cm (⅜in) across in each corner and then mark 1cm (⅜in) increments along the top and bottom of the page so you've got two rows of dotted lines.

2. Using your craft knife and ruler on a cutting mat, score between the top and bottom points to make a series of vertical lines. Using your knife and ruler, cut along all the vertical lines. With your other piece of paper, mark out horizontal strips that are 1cm (⅜in) thick each and cut them out with your knife.

3. Now let's weave! Flip your base paper over so you can't see the pencil marks. Take one strip of paper and work from one side, pulling it over and under until you reach the other side of the paper. Gently slide the strip up to the top of the cut.

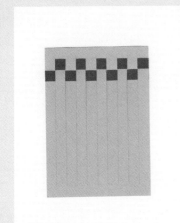

4. Repeat with your second strip, this time alternating the way you weave. If you started by going over your first segment last time, go under it this time.

5. Repeat this process until you've used all your strips, alternating whether you go over or under each time so that a check pattern emerges. Once you've pulled each strip through, push it up so that it meets with the line above.

6. Use your craft knife to neaten up any strips hanging over the edge of the paper and dab the ends of each with a little glue to hold.

Top tip: The final strips you weave through can be a little fiddly. You might find it easier to flip the base paper over each time you weave it through so that you can see it and guide it with your fingers.

Idea: Now try using a whole rainbow of colours!

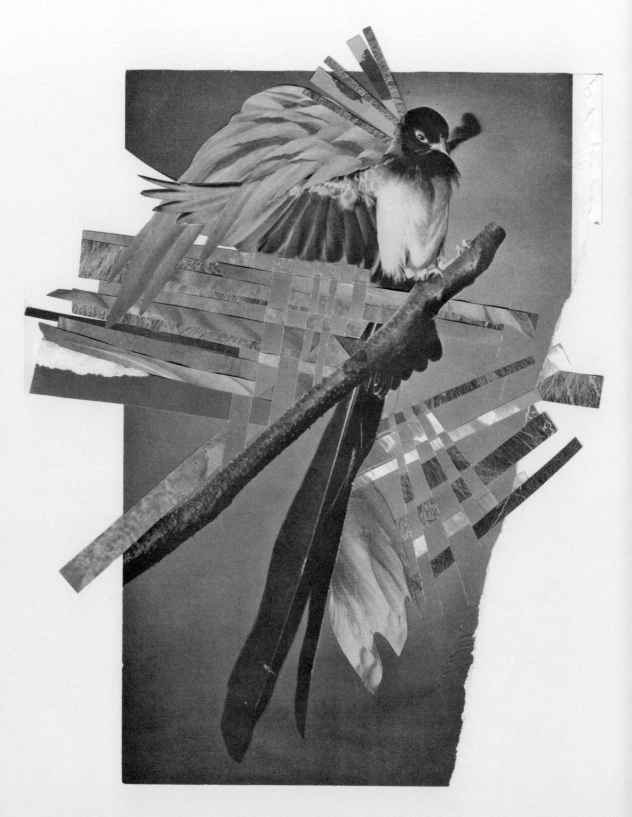

Beyond the flat page

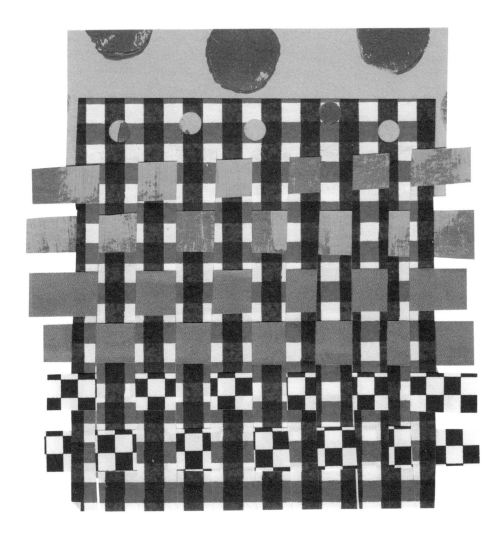

Weaving combined with found imagery

Weaving is a fun way of manipulating or adding to a found image, too. Remember, the back can be just as fabulous as the front.

Pattern example

The same technique has been used here, but the overall effect is more complex, thanks to the patterned and painted papers used. Bigger gaps have been left between the strips and the edges have been left untouched for a looser aesthetic.

Although collage making is an excellent solo pursuit, there are wonderful ways to experience it with others, too. I love the social element the medium allows for, sharing materials and techniques around one big table, borrowing scissors and ideas from each other along the way.

COLLABORATIVE COLLAGING

Materials
A4 (letter) base paper
 (one for each player)
Scissors
Glue
Magazines
Colourful paper
You might also want to
 add stickers, tapes,
 shapes and any other
 bits and bobs you
 have lying around

Invite your friends or family to join in a creative session, or gather a group of creatives in your area that you'd like to connect with. As well as working on individual pieces, dedicate some time to working collaboratively. Having multiple visual voices working together can bring new perspectives and skills you wouldn't have thought of by yourself.

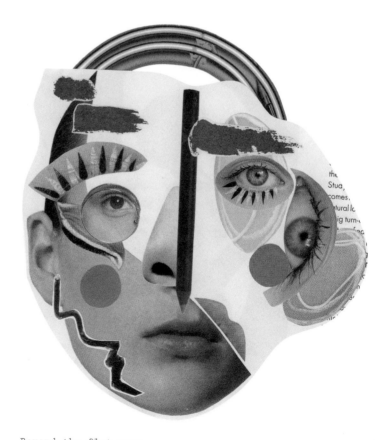

Exquisite corpses

You may remember this activity from your childhood. Cadavre exquis (exquisite corpse) was a game conjured up by the Surrealists in the mid-1920s, and it saw three or four participants working collaboratively to create weird and wonderful bodies. Each would add to the page in turn, without revealing to the others what they had drawn, written or collaged. Once opened up, they would reveal strange creations pieced together from human, animal and mechanical parts.

Have a go with your own group and challenge yourselves to dream up seriously surreal creatures. Set a time limit for each section, say five or ten minutes, to add some extra excitement to the proceedings.

1. Divide your page into three, folding it from the top to the middle point, and then back on itself to form three equal sections.

2. Start with just the top section – this will be where your head goes. It could be human, animal or an anthropomorphized object. Remember to add a neck and let a tiny part of it spill into the next section so your collaborator knows where the shoulders should start. Use features found in magazines, or cut eyes, ears and mouths from colourful paper.

3. Once you've finished the head, fold the top section back on itself so the person next to you can't see it. Pass it on so each participant is working on a new sheet. This middle section will be for the torso, arms and hands. Collage to about hip height, again hinting to the person next to you where to start the legs in the next section. Fold it over again to keep your work secret and pass it on one last time.

4. This final section is for legs and feet. Don't feel constrained by the bottom edge of the paper. Your collaged limbs could be so long they stretch way beyond the end of the sheet!

5. When finished, open up your pieces of paper to reveal incredible bodies. Do they resemble humans or are they from another galaxy completely?

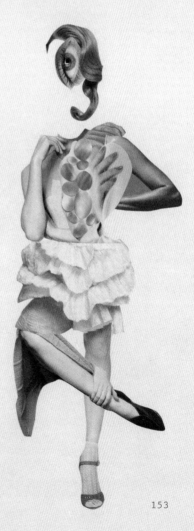

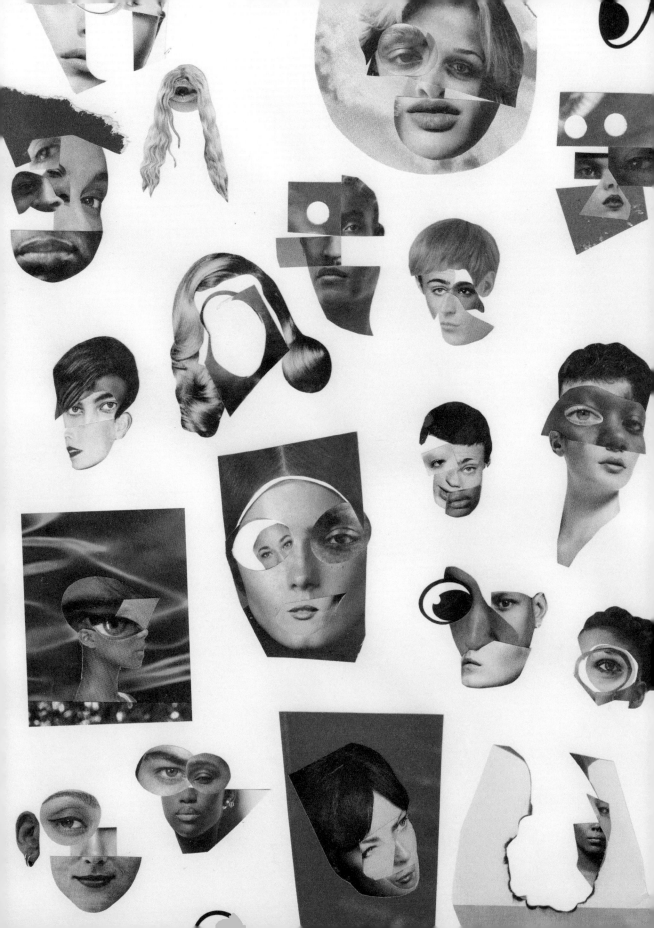

Challenge each other to create the strangest characters you possibly can!

IDEAS FOR EACH SECTION

Head:

Human
Animal
Giant ears
Hair that extends beyond
 the top of your page
Astronaut helmet
Multiple heads
Alien
Hundreds of eyes
Statement glasses

Body and arms:

Wings
Tentacles
Paws
Claws
Bodybuilder torso
Floral shirt
Feathers
Tattoos

Legs and feet:

Spider legs
High heels
Clown shoes
Mermaid tail
Football boots
Giraffe legs
Robot
Wheels
Disco flares

Use this technique to form
collages on lots of different
themes.

Buildings

Top section: domed roofs,
 spires, rooftop gardens
 and swimming pools
Middle section: window-
 clad skyscrapers, ornate
 palace façades
Bottom section: a cottage
 door with a pretty
 garden and picket
 fence, an underwater
 submarine dwelling or
 a house on stilts

Ice cream sundaes

Divide the page in two
 and form outrageous,
 sweet treats. Use the
 top section to collage
 ice creams laden with
 sprinkles, fruit, sauce
 and sparklers and the
 bottom for ornate,
 decorative vessels to
 hold your dessert.

Flowers and vases

Machines

Hybrid vehicles

Turn your page horizontal
 for this.

Zines, or fanzines, are self-published works that often combine text and imagery on a specific subject. They first emerged in America in the 1930s, when sci-fi fans started making their own fan magazines featuring stories they'd written. In the '70s, the DIY ethos of the British punk scene and access to photocopying made zine self-publishing explode in a big way, before a wave of underground feminist zines such as Riot Grrrl emerged in the '90s. They often represent alternative narratives, subcultures and marginalized voices, but their subject matter can be wide ranging.

COLLABORATIVE ZINES

Your collaborative zine could be about music, politics, art, race, gender, poetry or something you all feel passionately about as a group. Collage, perhaps! Think of your zine as a vehicle for expressing messages and ideas in a fun, informal way. Combine pictures, photographs, text and drawings to create a publication brimming with energy.

The easiest way to make a zine is by folding a sheet of paper. You could each design a couple of pages, then set to work photocopying and distributing it to others. Don't forget to give it a name.

HOW TO MAKE A ZINE

Beyond the flat page

ARTIST SPOTLIGHT

Rubbish FAMzine is an incredible example of collaboration. Pann and Claire Lim and their two children have been making it since 2013, from their home in Singapore. Each issue is presented in surprising and exciting formats. Although produced digitally, the family hand-finishes each copy (300 per issue) with stickers, inserts and special touches. A personal favourite of mine is issue six, which is about the family's love for food. It comes packaged in a take-out box and is jammed with family photos, sticker sheets and a series of haikus written by the kids about their favourite canned delicacies. It'll give you food for thought when designing your own collaged publications!

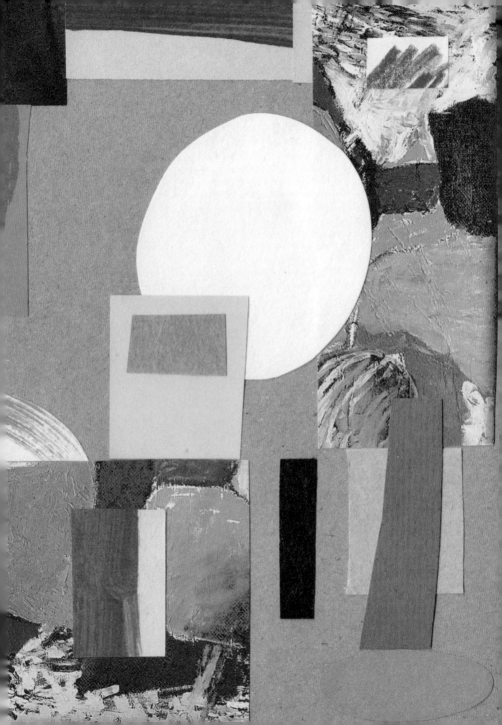

These collages were made in collaboration with Bristol-based artist Ed Cheverton (b. 1991). We each began a series of 'starts', popping them in the post for the other person to finish off. There's always an element of surprise when working this way, as there's no telling how your collaborator will interpret your work. Embrace the unexpectedness!

COLLAGE CORRESPONDENCE

Begin a number of abstract collages, leaving plenty of space for more elements to be added by someone else. Make them postcard size for easy sending, and keep nice envelopes and stationery you receive for mixed-media collages.

An Hachette UK Company
www.hachette.co.uk

First published in Great Britain in 2023
by ILEX,
an imprint of Octopus Publishing
Group Ltd
Carmelite House
50 Victoria Embankment
London EC4Y 0DZ
www.octopusbooks.co.uk
www.octopusbooksusa.com

Distributed in the US by
Hachette Book Group
1290 Avenue of the Americas
4th and 5th Floors
New York, NY 10104

Distributed in Canada by
Canadian Manda Group
664 Annette St.
Toronto, Ontario, Canada
M6S 2C8

Publisher: Alison Starling
Commissioning Editor: Ellie Corbett
Managing Editor: Rachel Silverlight
Editorial Assistant: Jeannie Stanley
Art Director: Ben Gardiner
Picture Research Manager: Giulia
 Hetherington
Production Manager: Lisa Pinnell

ISBN 978-1-78157-866-7

A CIP catalogue record for this book is
available from the British Library
Printed and bound in China

10 9 8 7 6 5 4 3 2 1

MIX
Paper | Supporting
responsible forestry
FSC® C008047

ACKNOWLEDGEMENTS

This book is dedicated to my
wonderful parents – Mum for
encouraging my creativity so
passionately and Dad for showing
me the true meaning of resilience,
especially during the last year.

A huge thanks to Sam B for
photography help and for being an
all-round legend, and to Agostino,
Nina, Shamoni and Tasha for
checking in and cheering me on. To
Ben and Jeannie at Ilex, and to my
commissioning editor Ellie for her
support and kindness throughout
the whole process.

Thank you to everyone who has
ever been to one of my Collage
Club workshops and enabled me to
do what I love for a living – there's
no way I would be writing this book
without you!

And finally, the biggest thank you
to Sam. You're the very best.

ADDITIONAL RESOURCES

Books

Cut and Paste: 400 Years of Collage by Patrick Elliott, Dr Freya Gowrley and Yuval Etgar

Collage by Women: 50 Essential Contemporary Artists by Rebeka Elizegi

Collage by Herta Wescher

The Art of Eric Carle by Eric Carle

Black Collagists: The Book by Teri Henderson

The Age of Collage Vol. 3: Contemporary Collage in Modern Art by Dennis Busch and Francesca Gavin

Shops

GreatArt, 49 Kingsland
Road, London E2 8AG
greatart.co.uk

London Graphic Centre
16-18 Shelton Street
London WC2H 9JL
londongraphics.co.uk

Fred Aldous
37 Lever Street
Manchester M1 1LW
fredaldous.co.uk

Cass Art, 14 UK stores
cassart.co.uk

The Southbank Art
Company, 21 London
Road, London SE1 6JX
southbankart.co.uk

Choosing Keeping,
21 Tower Street
London WC2H 9NS
choosingkeeping.com